# KINGSTON-UPON-THAMES
## THROUGH TIME
Tim Everson

AMBERLEY

*In memory of Tom, 1985–2001*

First published 2010
This edition published 2015

Amberley Publishing
The Hill, Stroud,
Gloucestershire, GL5 4EP

www.amberley-books.com

Copyright © Tim Everson, 2010, 2015

The right of Tim Everson to be identified as the
Author of this work has been asserted in accordance
with the Copyrights, Designs and Patents Act 1988.

ISBN 978 1 4456 5017 3 (print)
ISBN 978 1 4456 5018 0 (ebook)

British Library Cataloguing in Publication Data.
A catalogue record for this book is available from
the British Library.

Typesetting by Amberley Publishing.
Printed in the UK.

# Introduction

Kingston-upon-Thames has a long and illustrious history. The first mention we have is from a document of 838 in which it is called "that famous place in Surrey". Kingston means King's Estate and the area on which the town now stands was owned by Kings of Wessex who later became Kings of all England. Two of those kings, Athelstan in 924 and Æthelred the Unready in 979, were certainly crowned in Kingston, and the traditional number is seven kings from Edward the Elder in 900 to Æthelred the Unready, omitting only Edgar who was crowned at Bath. The other tradition is that they were crowned on the Coronation Stone which now sits by Kingston's Guildhall but may soon be moved to a more prominent position north of the church. The stone was only recognised as possibly a coronation stone in the eighteenth century so this tradition is somewhat more tenuous.

Kingston as a town began in the twelfth century. A church, All Saints, had existed since before Domesday in 1086, but now a market area was laid out to the south, a planned town in effect. Clattern Bridge was built to cross the Hogsmill to the south, and the first reference to Kingston Bridge is to it being repaired in 1194, which shows its early date. In fact Kingston Bridge was the only bridge across the Thames apart from London Bridge until the eighteenth century. Tolls had to be paid to cross the bridge or pass boats under the bridge and Kingston's prosperity began with this. However since then Kingston has been known as simply a shopping town and perhaps lacking in culture. This is a little unfair. It has a splendid museum by the library in Wheatfield Way, which charts the history of the local area, and it now has a theatre to be proud of in The Rose in the High Street. It is also an excellent base for visiting Hampton Court.

Shopping and culture are certainly the assets Kingston possesses today. There is no longer any industry such as those that appear in some of the following pages. Kingston's major industries developed

from the Middle Ages were tanning and brewing, which lasted through to Victorian times and beyond. The aviation industry was also a big employer from the First World War onwards, and there was also boat building. Kingston's industry can be said to have ended between 1989–92 when both the Vinery, manufacturing British Sherry, and British Aerospace, manufacturing Harrier Jump Jets, closed their sites down.

Looking through these photographs of Kingston past and present, I was struck by several things, not all of them obvious. One obvious change is the busyness of Kingston. Few of the modern photographs have no cars present, and sometimes it was quite impossible to stand where a Victorian predecessor had stood without a good chance of getting knocked down! I was also surprised at the rapidity of change in shop ownership. I knew that Kingston was not the same as it was thirty years ago, but actually it is quite different from ten years ago, and I came across some shops that have barely survived a year. Whilst Kingston has managed to preserve many of its important historical buildings, there are some sad losses. People still talk to me about the Old Malt House in the High Street, cruelly demolished in 1960, but I was shocked to see how many beautiful Victorian gothic churches had been pulled down in the 1950s. On the positive side, and surprisingly so, Kingston is a much greener place than in Victorian times. Planners today are much keener on inserting trees and flower beds, and those trees planted some time ago are now bigger and better, sometimes making photography tricky! I hope you enjoy this selection and that it brings back many memories.

I am grateful for the opportunity to update all the modern photographs for this second edition. It is quite amazing how much has changed in Kingston in just five years, from major developments like the revamped Market Place, All Saints church and Kingston Riverside apartments, to the constant changing of the shops. Despite the controversial nature of some of these changes, Kingston remains a wonderful town to live in or to explore and I hope that you enjoy this updated selection of pictures.

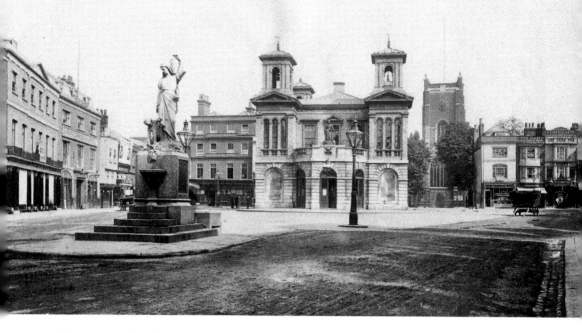

## Kingston Market Place

The heart of Kingston is its Market Place, laid out in the late twelfth century to the south of All Saints church. The Market House was built in 1840, replacing an earlier version with parts dating back to Henry VII. The early photograph dates to *c.* 1900 and was taken very early on a Sunday morning to be this quiet. The modern photograph shows the new dark paving and permanent wooden market stalls which were laid out in 2014 when Kingston market became a food only market.

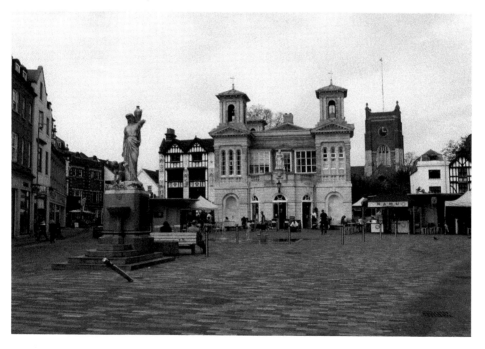

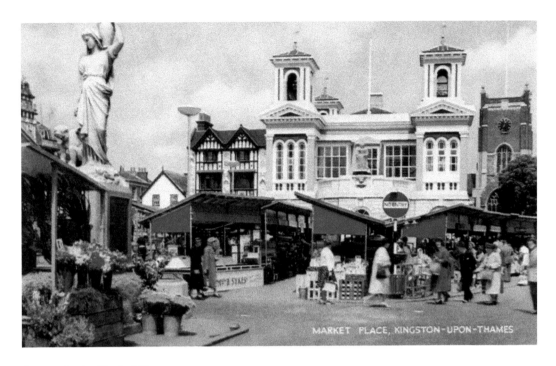

MARKET PLACE, KINGSTON-UPON-THAMES

## Statues in the Market Place

A busier Market Place from a postcard of 1970 shows a good view of the Shrubsole fountain. Henry Shrubsole was elected mayor in 1877, 1878 and 1879, dying in office during his third consecutive term. The people of Kingston erected this fountain in his honour. The left arm is missing again at the moment, a common occurrence since it was first broken in the 1970s. The gold statue on the front of the Market House is of Queen Anne and dates to 1706. All Saints church is on the right.

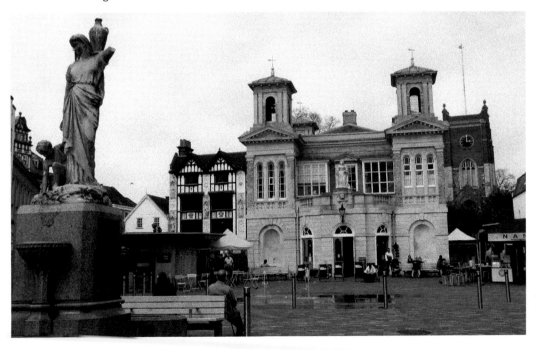

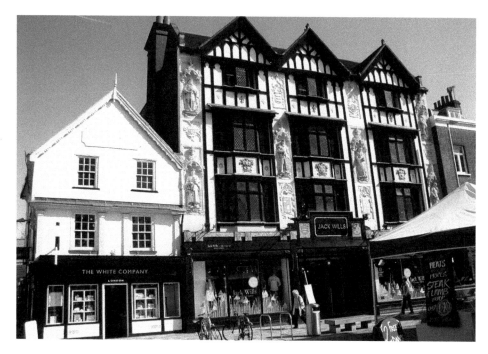

## Not What it Seems

The magnificent Market Place building on the right of this picture is sometimes thought by visitors to be a medieval wonder. It is in fact Edwardian and was Phillipson's Library until Boots bought the site in 1908. The left and central sections were covered with mock Tudor embellishments to the design of Mayor Finny, with the right hand section being added in 1929. Boots moved to Eden Walk in the 1980s and the site was taken over by Next. They were replaced by Jack Wills in 2012 with The White Company taking over the premises on the left. This small nondescript building is in fact genuinely one of Kingston's oldest buildings, dating to around 1500.

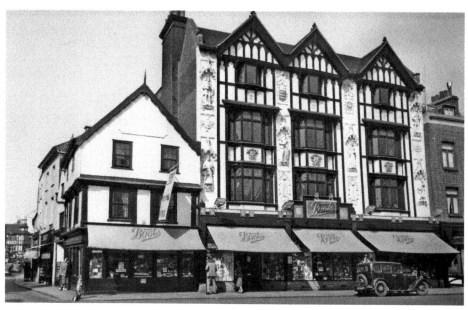

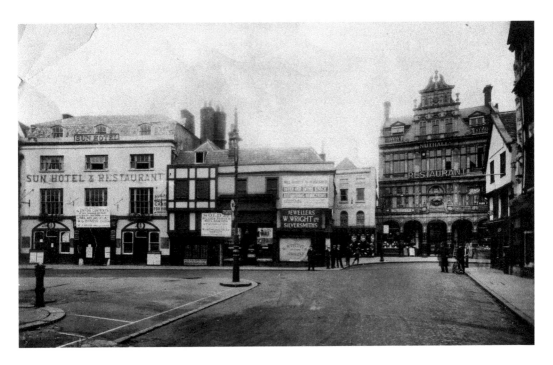

### The North West Corner of the Market Place

The Sun Hotel at the north end of the Market Place was one of Kingston's oldest coaching inns, dating back to before 1400 when it was called the Saracen's Head. It was especially famed for its riverside gardens. The top photograph was taken in 1931, just after it had been bought by Woolworths, who demolished and rebuilt it. Woolworths themselves famously disappeared in 2009. Clas Ohlson now occupies their old premises.

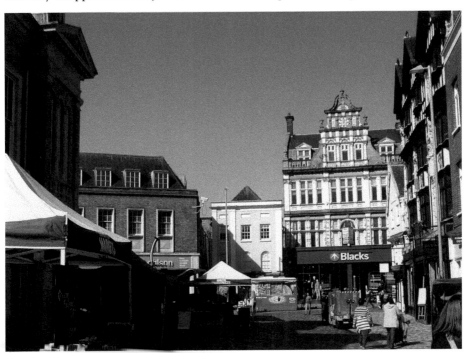

## Dutch Kingston

This well known 'Dutch-fronted' shop in Thames Street was built in 1902 by Nuthalls, a restaurant and catering business in Kingston since the time of William IV. The top photograph is from 1917. Later on, the site was occupied by British Home Stores. They moved to the new Eden Walk shopping arcade in 1980. Millets – the camping and outdoors suppliers – took over the site though the store has been renamed Blacks following an amalgamation. As with many Kingston buildings, a modern shop front has quite spoilt the ground floor.

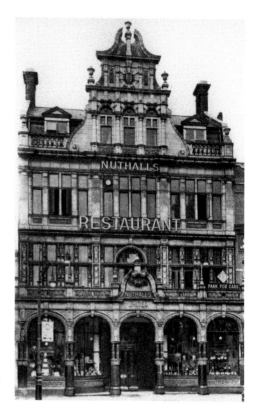

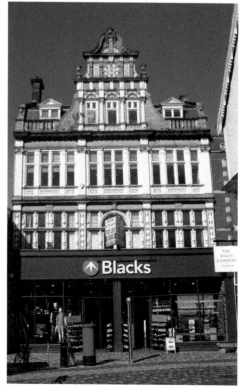

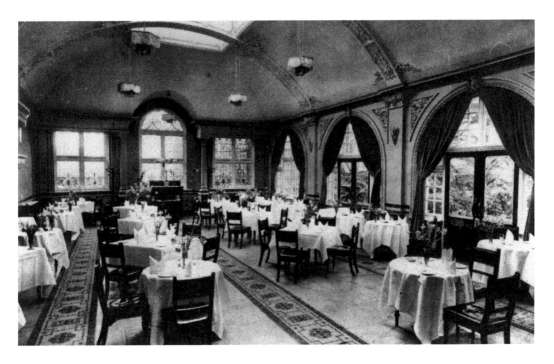

### Nuthalls Restaurant

Inside Nuthalls, again in 1917, this is the Rosebery Hall restaurant and tearooms, which must have been struggling at this time with the food shortages caused by Germany's U-boat campaign. The rooms are sadly no longer in existence. Millets did have a restaurant here called Bridges but – despite the sign – it is longer in existence. The area is now used for staff training purposes.

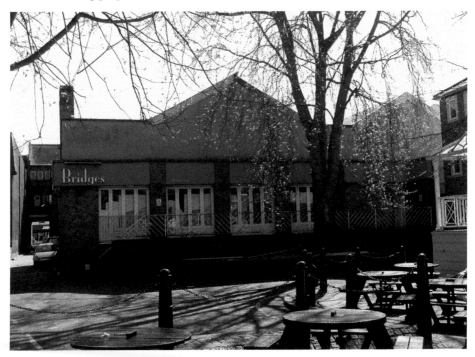

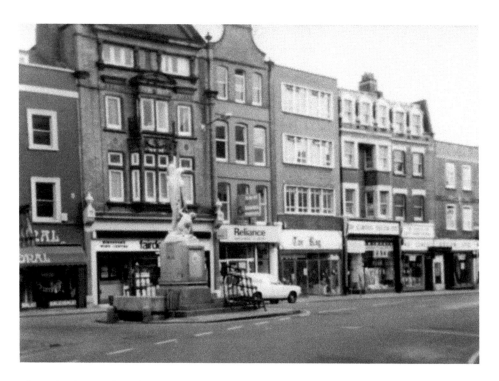

### Shops in the Market Place

The top photograph of the south-east side of the Market Place can be dated to 1976 by the Toe Rag clothes shop which only existed for about a year. It is now Food for Thought. In fact none of the 1976 shops survive. Behind the Shrubsole fountain was Fairdeal, an off-licence, now Fired Earth. Next door to that was Reliance, an employment agency. Both these lasted about ten years. Classic Décor on the right of Toe Rag lasted for over twenty years, from 1963 to 1984.

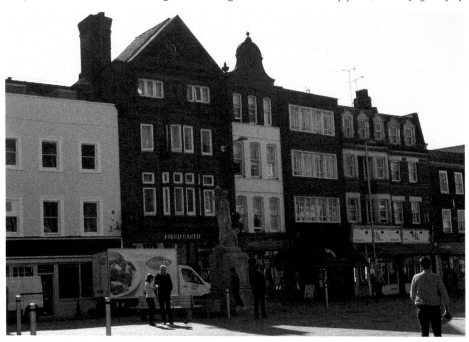

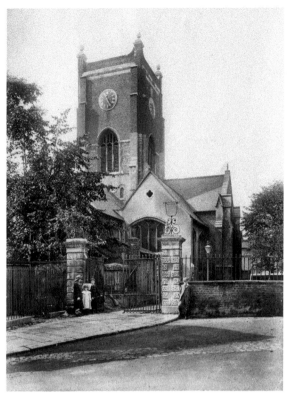

## All Saints Church

All Saints church is positioned just north of the Market Place in the old centre of the town. In fact, in Saxon times, the Church and Market area was an island between two branches of the Thames. An Anglo-Saxon chapel stood just to the south of the church until 1730 when it fell onto the Sexton digging graves and killed him. The church itself is mentioned in the Domesday Book, at about the time is was first built in stone.

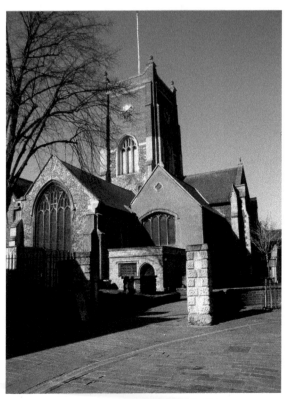

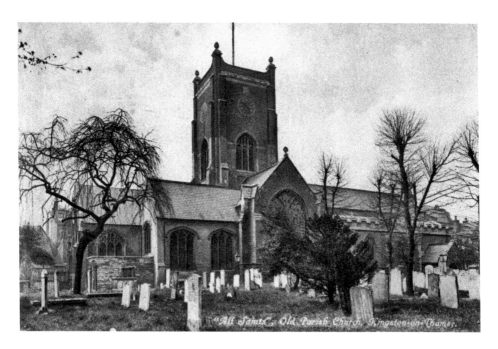

## The Old Graveyard

Substantially rebuilt in the twelfth century, All Saints has been added to and repaired many times. It originally had a spire which was destroyed by a lightning strike in 1703. The tower visible today is mostly Georgian and was extensively repaired in the 1970s. All Saints church is currently being extensively refurbished and the new north door is clearly visible. 'Where England Began' refers to the crowning of King Athelstan in Kingston in 924.

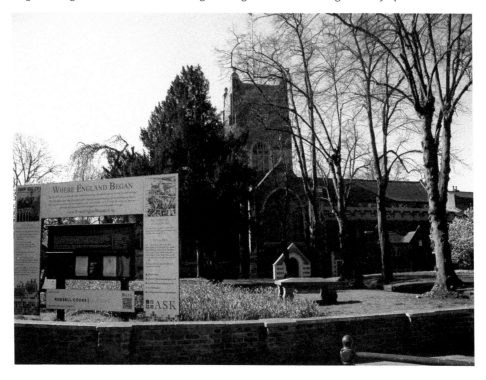

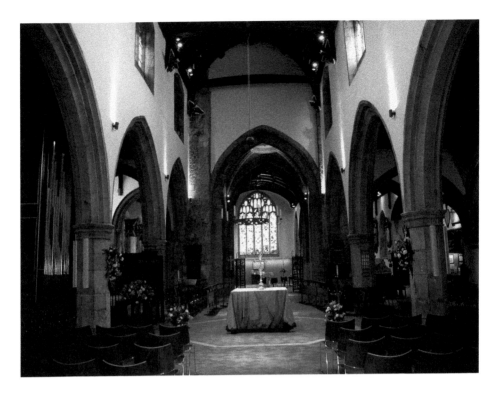

## Gothic Interior

Originally a Romanesque church, later rebuilding was in the Gothic style. The church floor has been retiled over the course of the last couple of years and the altar now sits in the centre of the church, rather than at the east end. The wooden angels supporting the roof timbers have also had their wings gilded.

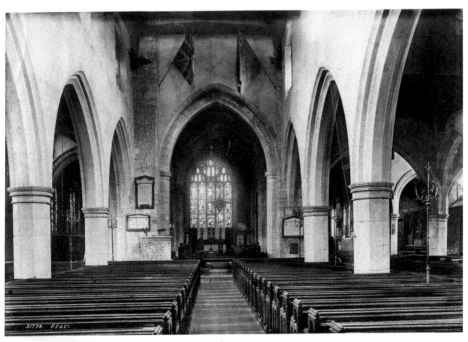

**Our Glorious Dead**

Kingston's War Memorial in Church Street, a figure representing strength and freedom, was designed by Capt. R. R. Goulden, and cast at Mr Burton's Thames Ditton bronze foundry. It was unveiled by Mr Penny, MP for Kingston, on Armistice Day, 11 November 1923. Kingston lists over 600 dead on its memorial for the First World War, but the full total probably nears 1,000, many from the local East Surrey Regiment.

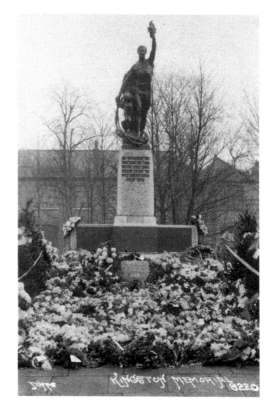

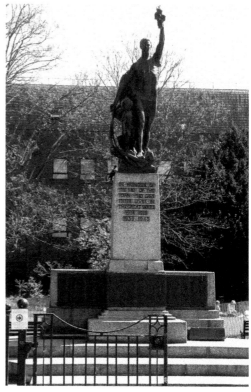

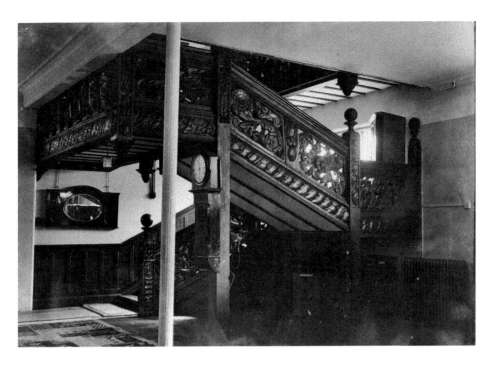

**Ruined Staircase**

This seventeenth-century staircase was in the Castle Inn on the west side of the Market Place which closed early in Victoria's reign. Although the pub was demolished, the staircase survived, sometimes precariously, in a succession of department stores on the site, the best known being Hide's. In the early years of this century the site was occupied by Borders bookshop who restored and added to the staircase but, since Next took over in 2011, it has been boxed in and is now difficult to view.

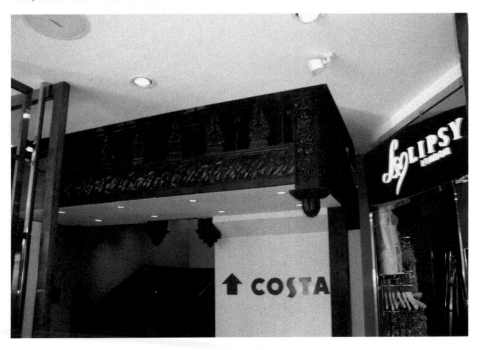

**A Short-lived Chemist Shop**
This is 32-3 Market Place by Harrow passage, the long-time home of Follets the butcher until this Drugmart store was opened in 1970. The AD 1422 on the wall is an Edwardian lie of obscure origin. No part of the building dates before 1500. Drugmart folded in 1977 to be replaced by Wallspan Bedding, then Laura Ashley, Kew, and now Joules Ladieswear. Unlike Blacks mentioned on p. 9, Joules has a shop front much more in keeping with the rest of the building.

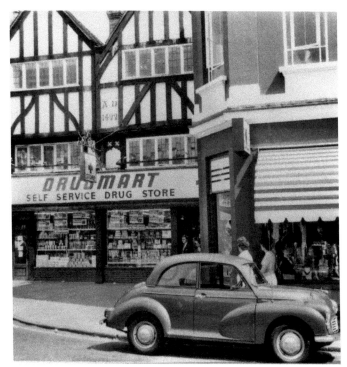

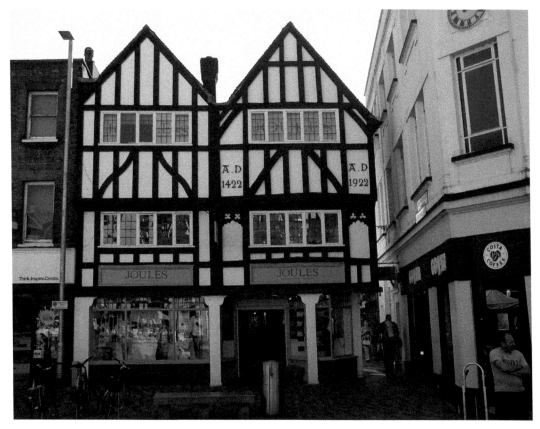

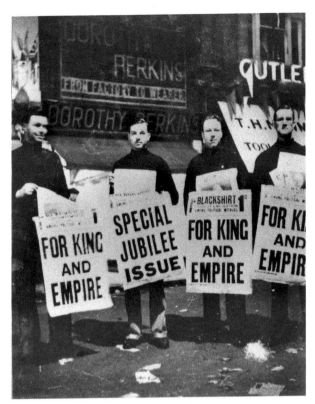

**Fascists in Kingston**
Here are members of the British Union of Fascists selling a special edition of their newspaper *Blackshirt* to celebrate the Silver Jubilee of George V in 1935. They are pictured outside Dorothy Perkins, No. 21 in the Market Place with Newman's Ironmongers shop to the right. Leading fascists, like John Nickells (third from left), were rounded up in 1940 and interned on the Isle of Man. Today, the Sunglass Hut is much less intimidating!

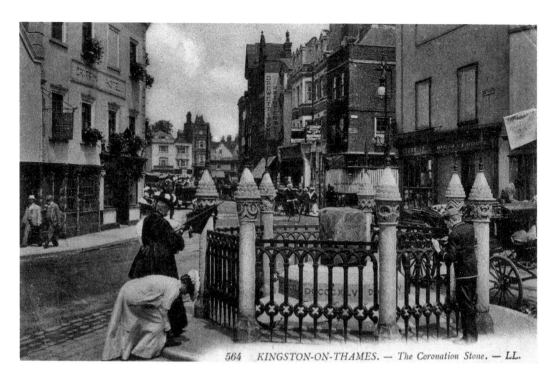

564 KINGSTON-ON-THAMES. — *The Coronation Stone.* — LL.

### Seat of Kings

The Coronation Stone is thought to be the stone on which perhaps as many as seven Anglo-Saxon kings of England were crowned. It was set up to the south of the Market Place within pillars and railings in 1850 where the two ladies above are waiting by it in *c.* 1900. It was removed to the front of the Guildhall in 1935 where it is safer, but invisible, and there are currently plans to move it to a more prominent position north of the church.

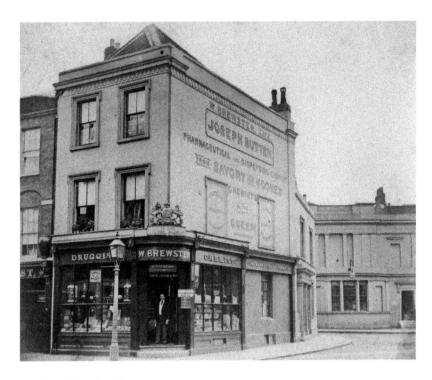

### Another Chemist Shop

This is No. 43 Market Place at the south end. Mr W. Brewster came to Kingston from Hampshire and took over this druggist/chemist store from Joseph Butten in about 1878. He closed in 1907, a few years after the above photograph was taken, and was eventually replaced by a fishmonger. The site has been a café and cake shop for several years but has undergone many name changes including Puccini's Café and Candy Cakes. It is currently Sweet Revenge.

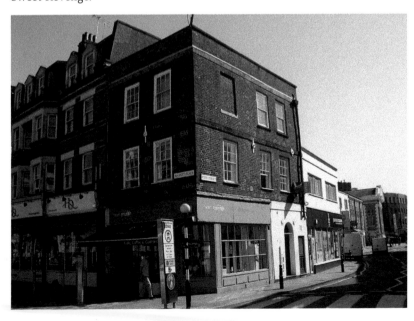

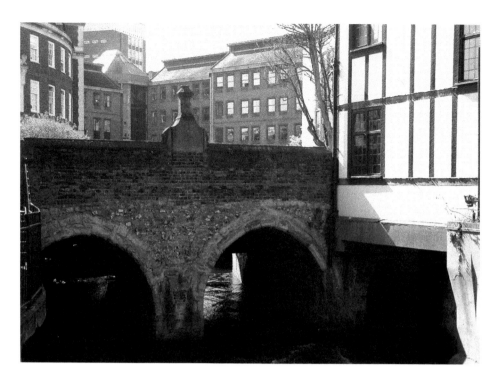

## Clattern Bridge

This bridge is the oldest stone 'building' in Kingston, dating to about 1200. It was placed to the south of the Market Place as a crossing point over the Hogsmill River and takes its name from the clattering of horses' hooves on its cobbles. The arches here are original, with Georgian and Victorian brickwork above. It has been widened many times as traffic has increased. The building to the right shows Edwardian 'Medieval' reconstruction replacing the original Victorian clapperboard.

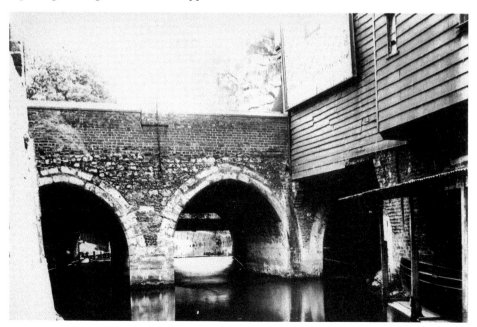

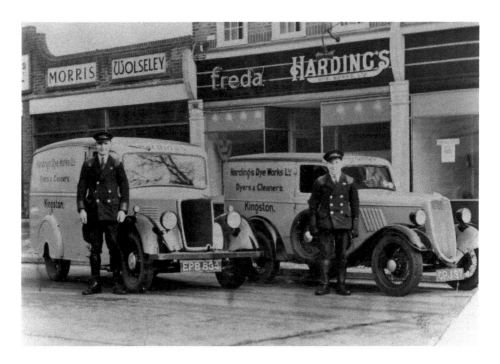

### Harding's Dye Works

Harding's Dye Works (and Laundry) had many different premises in Kingston at different times including Acre Road and Church Street, where they started in 1859. This is their office at 42 High Street in *c.* 1930 to where they moved in 1882. They were the first firm in Kingston to use motor vehicles. They bought their first in 1910 and sold off their last horses in 1914, probably to the army. The firm finally closed in 1989.

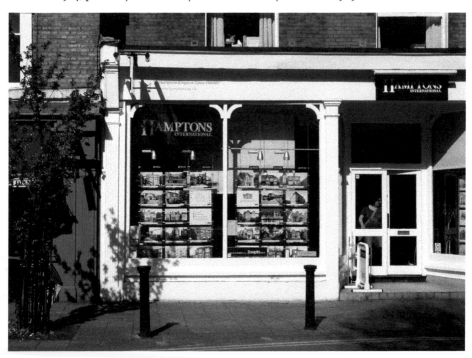

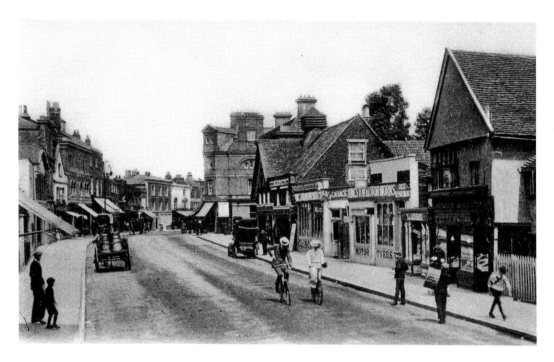

## The High Street

A view of the High Street in Kingston in Edwardian times shows the Old Malt House in the centre, which was illegally demolished in 1960. Hodgson's Brewery had stopped using it in 1890 when it became Smelt's Antique Shop. To the right was The Kingston Motor and Cycle Company which sold bicycles, motor cars and, until 1910, guns. After 1932, Smelt's took over their premises as well. These have all been demolished and replaced by a rather nondescript office block.

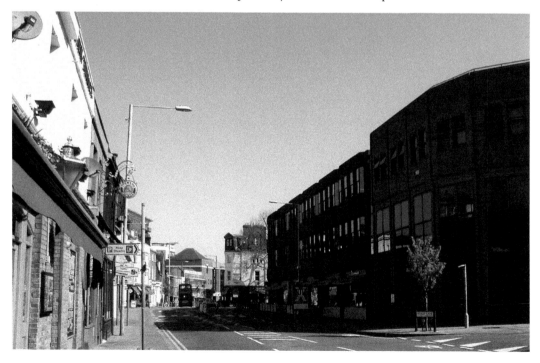

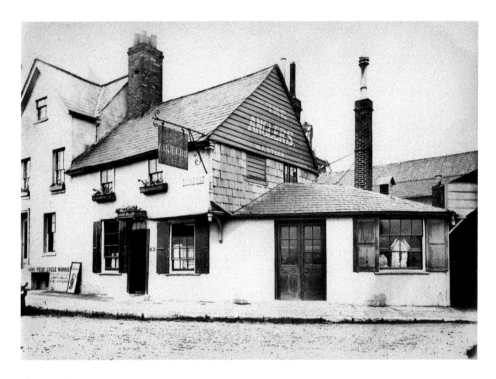

## The Anglers

The Anglers public house was at the junction where the High Street becomes the Portsmouth Road and where Kingston becomes Surbiton. Dating to before 1828, the Anglers ceased trading in 1958. Demolished shortly afterwards, it was replaced by these flats bearing the same name.

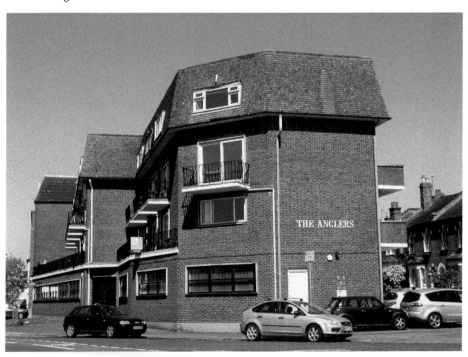

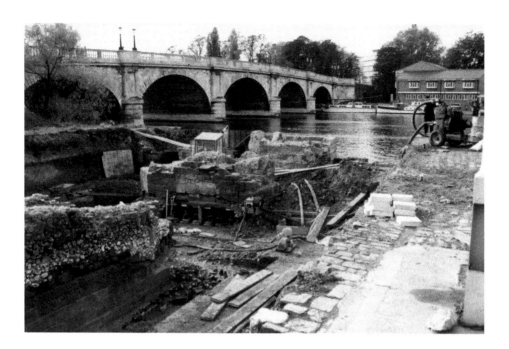

## Old and New Bridges

This is Kingston Bridge looking across to Hampton Wick from the north side of the bridge. Above can be seen the stone foundations of the original wooden bridge of the twelfth century which were excavated in the late 1980s. This rickety construction was repaired again and again until 1826 when the new stone bridge was built 100 yards further upstream. This new bridge was widened in 1914 to help accommodate the trams, and again in 1998–2000 to allow two lanes of traffic and a central bus lane.

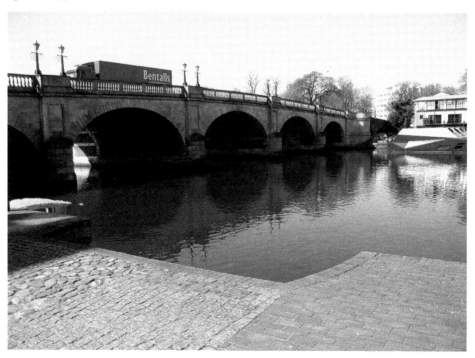

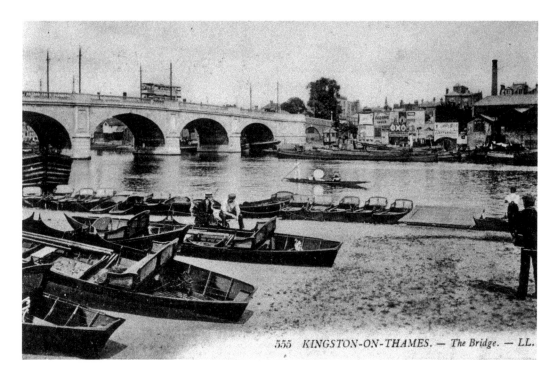

555 KINGSTON-ON-THAMES. — *The Bridge.* — LL.

### Kingston from the Middlesex Bank

This view of Kingston Bridge is taken from the Middlesex bank looking towards Kingston. The top photograph shows a tram halfway across the bridge and must date to shortly after 1906. Boating was a more popular pursuit in those days and there are many pleasure craft, including punts, waiting to go out on the river. Today the background is dominated by the Kingston Riverside apartments and John Lewis.

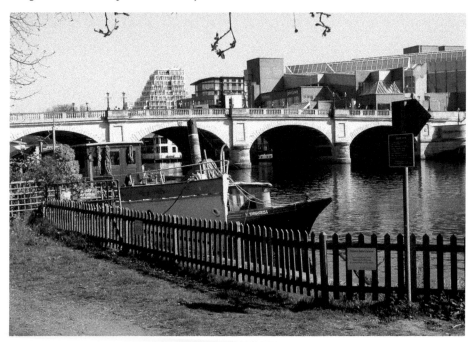

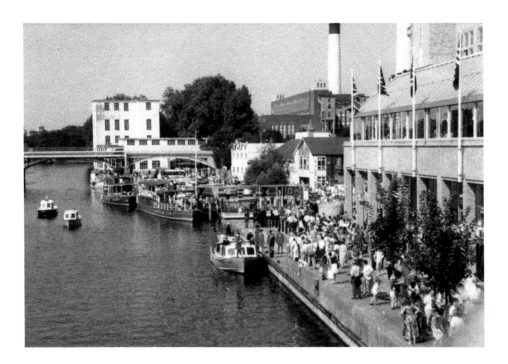

## Queen Elizabeth Visits

On the 29 July 1992, Elizabeth II arrived in Kingston by boat as part of the celebrations of the fortieth anniversary of her accession. Here, she is being greeted by the Mayor, David Edwards. In the background are the chimneys of Kingston Power Station which was opened by George VI in 1948. Never really big enough, it closed in 1980 and the chimneys were blown up in 1994. The site has now been covered with new housing.

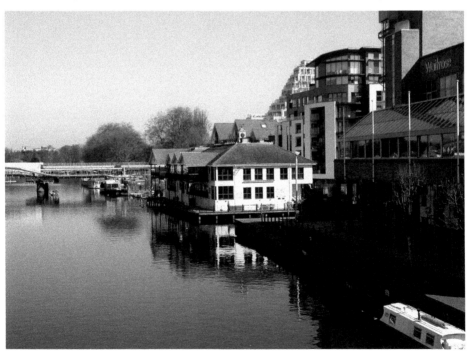

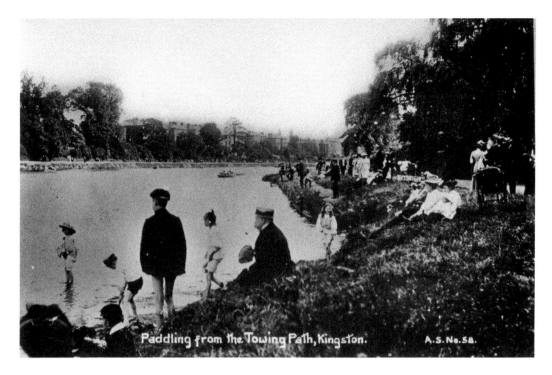

Paddling from the Towing Path, Kingston.      A.S. No. 58.

### Edwardian Paddlers

The Edwardian photograph above shows the Thames being used for paddling like a seaside resort. This is taken from Home Park looking across to the houses in the Portsmouth Road. Today the river has been dredged and banked, making paddling difficult. The river remains a great place to relax and watch the world go by, but paddling is now seldom encountered.

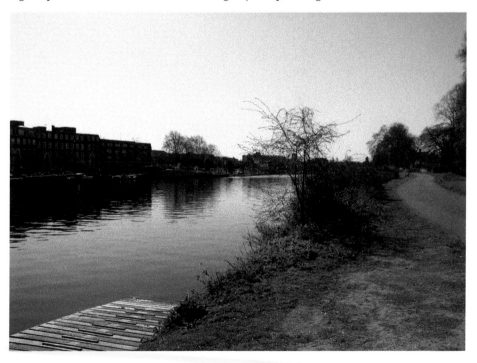

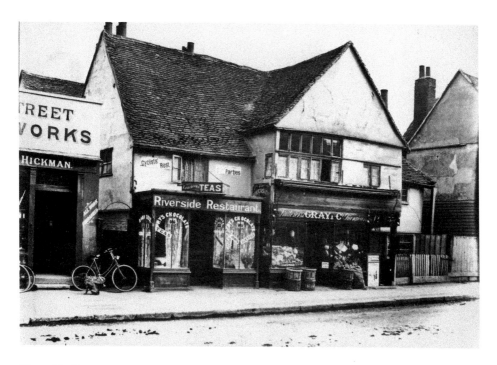

## Riverside Teas

The east side of the High Street showing numbers 31 and 33 in *c.* 1897. The Riverside Restaurant was run by Edward Lowrey who had come to Kingston from Dublin via Woolwich where he met his wife. His restaurant closed in 1905. Gray and Co. was a Fruiterer's founded in *c.* 1890 by Daniel Gray. It folded in 1898. The road to the right of the picture is East Lane.

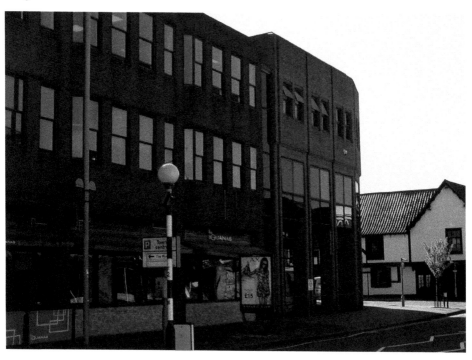

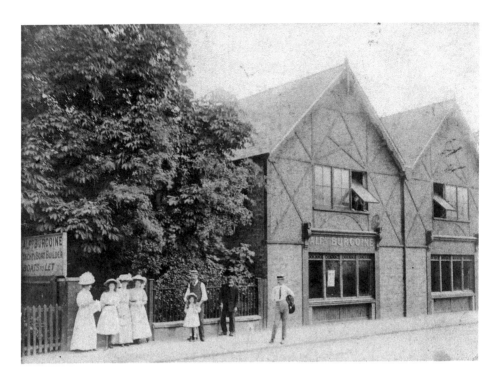

### Burgoine's Boat Yard

This was 22A in the High Street taken from the river. In the top picture the buildings belong to Burgoine's Boat Yard which closed in 1910. Various other boat builders and yacht clubs occupied the site after that, including Sammy Emms from the 1930s until 1980. The buildings were then demolished and became one of Kingston's many temporary car parks until these modern flats were built in 2003.

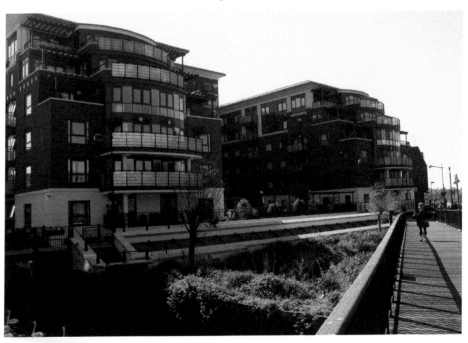

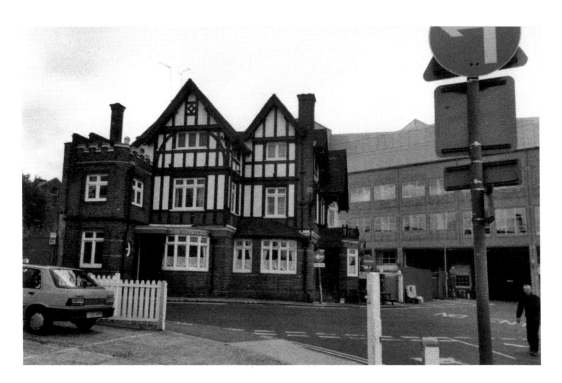

### The Outrigger

This is the old Outrigger pub dating to 1864. It was cut of from the rest of Kingston by the John Lewis development which can be seen in the background. It also lost customers to the Royal Barge and other new riverside pubs which were opened. It finally folded in 1997 and was demolished. It is now a derelict yard just beyond the new Steadfast Sea Cadets' building.

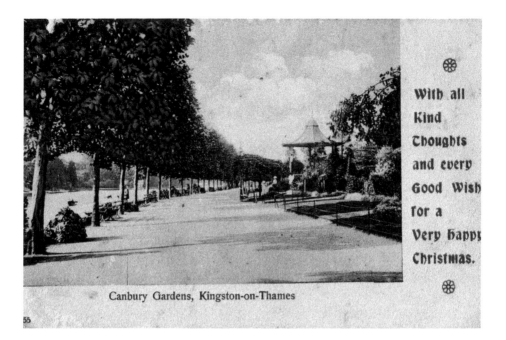

With all Kind Thoughts and every Good Wish for a Very happy Christmas.

Canbury Gardens, Kingston-on-Thames

55

### Canbury Gardens

Postcards of Kingston with added Christmas greetings were very popular in Edwardian Kingston and often occur with scenes that bear little relevance to Christmas, or even winter. In a hundred years the riverside trees here in Canbury Gardens have grown tremendously and now mostly obscure the bandstand. In fact, this is not actually the same bandstand. The original was taken down in the 1950s as unsafe, and a new one was erected on virtually the same spot in 1997.

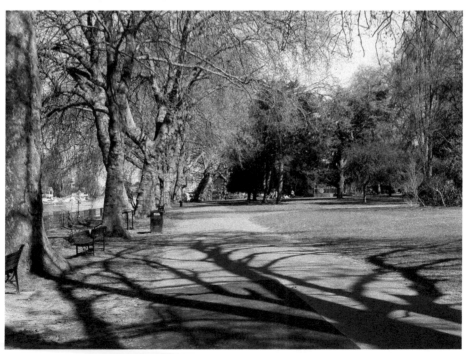

## Richmond Road by the Railway Bridge

This lovely old clapperboard house in Richmond Road was originally No. 16 Railway Coal Wharf. It was the property of Mrs Teresa Brick, a wardrobe dealer. In 1891 she is listed in the census as living at 21 Elm Crescent, a widow of sixty who was born in Dublin. She had presumably died by 1897 when this photograph was taken of her shop prior to demolition. The Blue Hawaii Restaurant stood here until 2010 when these student flats were built, resembling something from a giant Lego set. Below them is a Tesco Express.

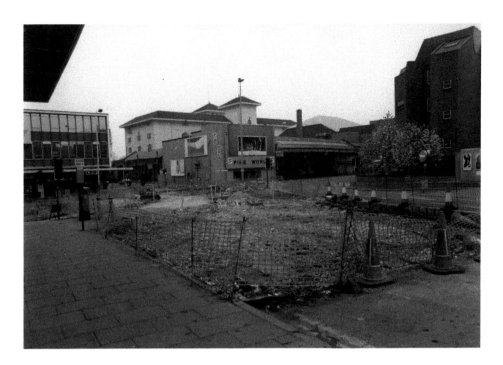

### The Rotunda

A view taken during the upheavals of 1989 when much of Kingston was made anew. Pine World was previously a cinema ending up with the name Studio Seven. To the right of that is Kingston bus garage. Both have now been demolished and replaced by the Rotunda, a cinema and leisure complex. Today the new student flats are on the left and there is a recently installed tourist information booth for people emerging from the station.

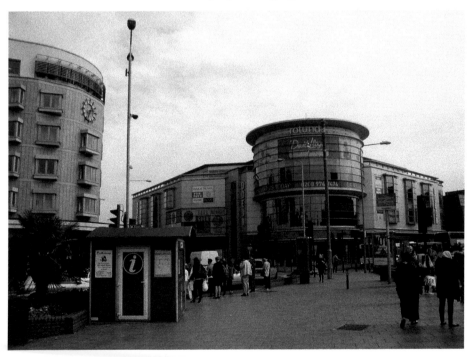

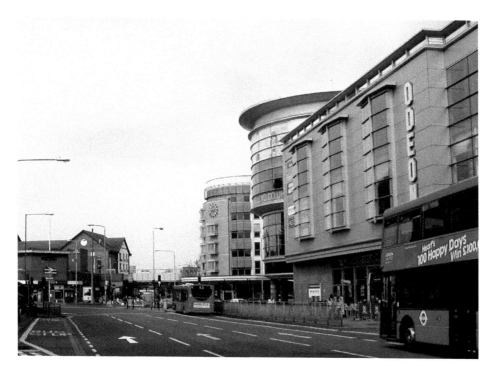

## Kingston Station

Kingston Station first opened in 1863 and was, fairly hideously, remodelled in the 1960s. This is looking north on the section of Richmond Road which may soon be renamed Empire Way. The bus station on the right finally closed its doors in 2000 and was replaced by the Rotunda cinema and leisure complex. On the right is the Odeon complex, the ground floor of which is a troublesome nightclub. Originally called Options, it was renamed Oceana in 2003. Since 2013 it has been Pryzm.

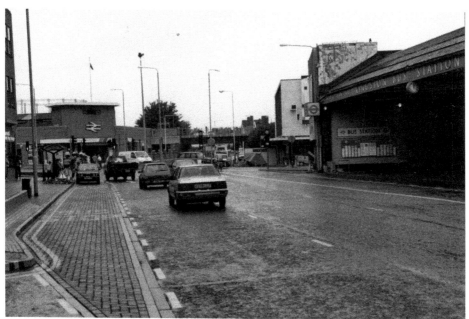

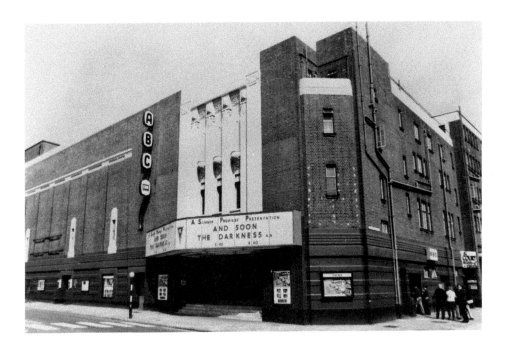

## Gala Days

The first cinema on this site further up the Richmond Road was the Cinema Palace, opened in 1909. It was never converted to play films with sound and was demolished in 1931. The Regal Cinema was opened by the Mayor in February 1932. It seated 3,000 and was famous for its Wurlitzer organ. It was renamed The ABC in 1960 but struggled like so many cinemas with the rise of television and closed in 1975. The building then became the home of Gala Bingo, which closed in 2010. The building will soon be converted into flats with a boutique cinema and community space.

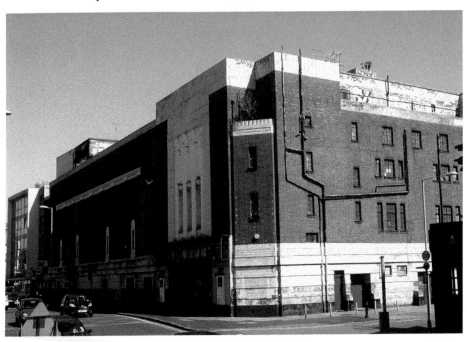

### A Bit of Old Kingston

This uninformative title frequently appears on old postcards of this alley with no further detail. It is in fact Harrow Passage, between the Market Place and the Apple Market, named after the Harrow public house on the right, which closed in 1912. It is now the back half of Joules, pictured earlier. The two pillars were made a hundred years ago by Mr Harris, ironmonger, and feature the three salmon of Kingston. Now moved from here, one at least is now in Crown Passage.

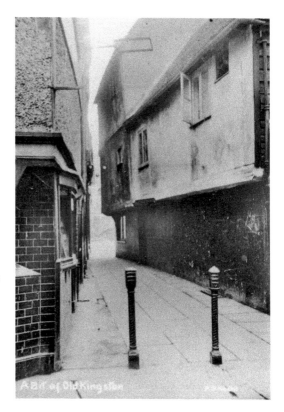

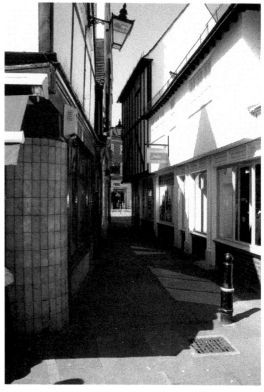

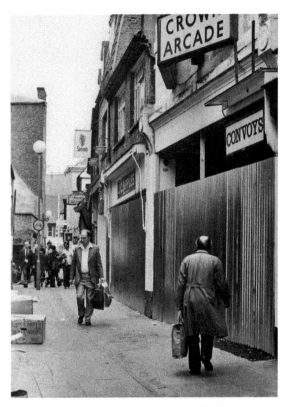

### Crown Passage

This is looking north up Crown Passage with Crown Arcade to the right. The picture above dates to 1980 and shows J. C. supplies (motor accessories), Glydon and Guess (watch repairs) Sirocco Ladieswear and Convoys Travel Agents. Glydon and Guess had been here since the war and J. C. Supplies since 1965. The others are short-term lets as the whole area was redeveloped in 1982.

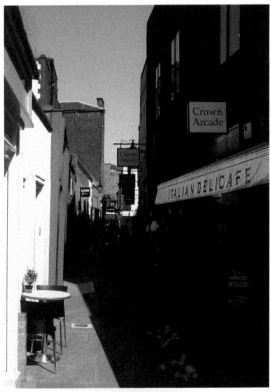

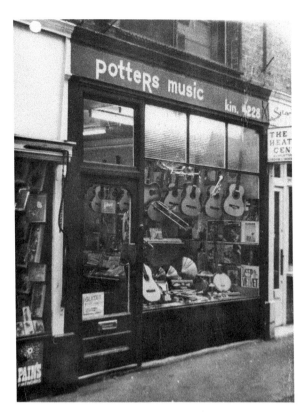

**Crown Passage Transformed**
An earlier photograph taken in Crown Passage, this shows Potters Music in 1968, just before they moved to Richmond. The Heating Centre is to the right. Potters Music was No. 4 Crown Passage but, after redevelopment and renumbering, the same site is slightly to the right of the present No. 1 Crown Passage!

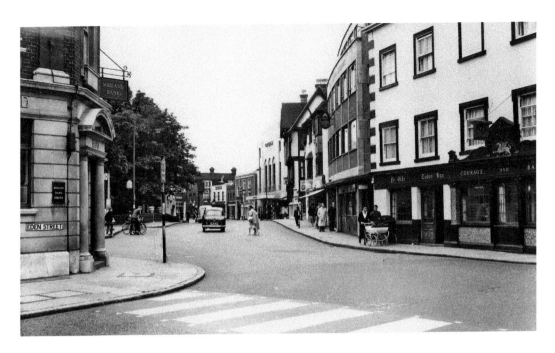

## From Cinema Back to Theatre

This picture is taken from the southern end of the Market Place looking down the High Street. In the distance on the right was Kingston's Odeon Cinema. This opened in 1933 with seating for 1,500 but only lasted until 1967 when it became The Top Rank Bingo Club. Following on from the great Charter Quay development and after a lot of angst (which still continues) about funding, Kingston's Rose Theatre opened on the site in 2008, ending a fifty-three-year period when Kingston was without a purpose built theatre.

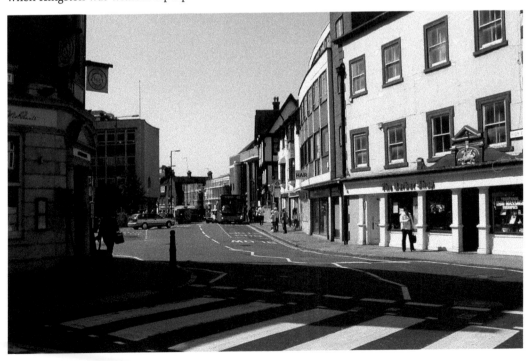

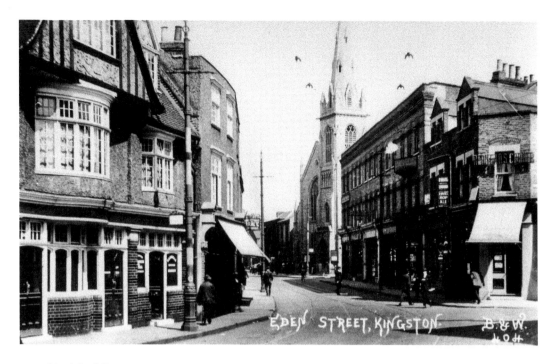

## Vanished Beauty

Eden Street has changed beyond recognition since this 1906 photograph. The public house on the left is the Three Compasses, new built at this time, which was demolished in the 1970s to make way for the Eden Walk development. The church in the centre was the Kingston Methodist (originally Wesleyan) church built in 1890. The congregation moved to Fairfield South, and this church was demolished in 1964.

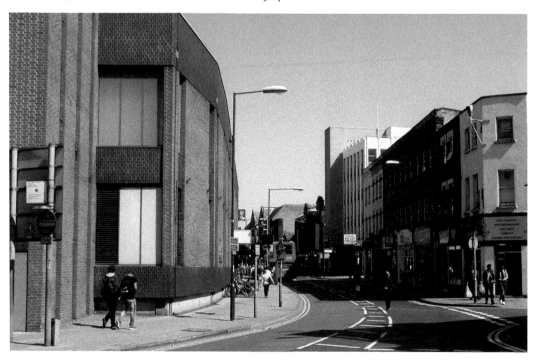

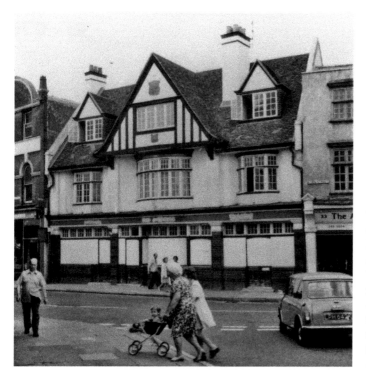

**The Three Compasses**
The Three Compasses public house photographed in the late 1970s after closure and before demolition. This building dated from 1906 although there had been a pub on the site since 1767 and probably earlier. The new Eden Walk shopping centre covered the site with British Home Stores as its flagship store. The mural on the wall features the seven Anglo-Saxon kings crowned at Kingston, and Victorian characters mentioned in G. W. Ayliffe's 1914 memoirs.

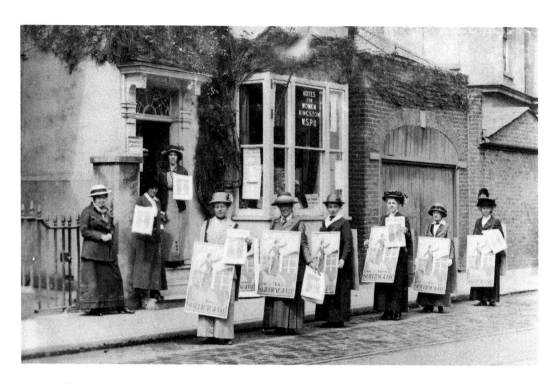

### Suffragettes in Eden Street

Unrecognisable today due to redevelopment and the building of the Eden Walk shopping centre, No. 53 Eden Street was the headquarters of the Kingston Branch of the Women's Social and Political Union. The Suffragettes, as they were more popularly known, were here for less than a year during 1914. Their activities were suspended at the outbreak of the First World War and by the war's end, most women had the vote.

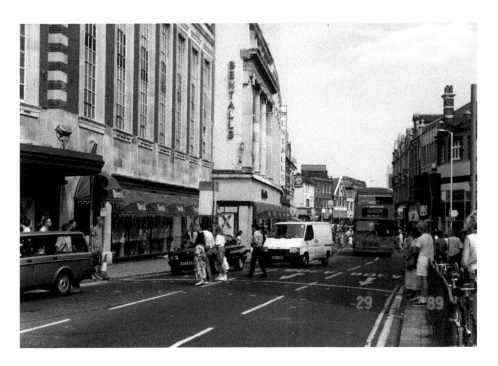

## Clarence Street Featuring Bentalls

29 July 1989 was the last day for traffic coming along Clarence Street before it was pedestrianised. As a small boy I remember the terrors of crossing the road outside Marks & Spencer's and, as a young driver, I remember inflicting those terrors! It is still quite tricky to cross from one side to the other given the numbers of pedestrians these days, not to mention wandering sandwich board people and chuggers (charity muggers!)

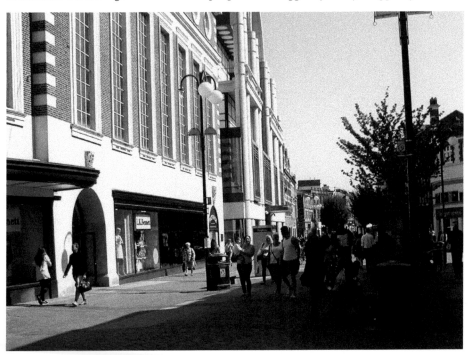

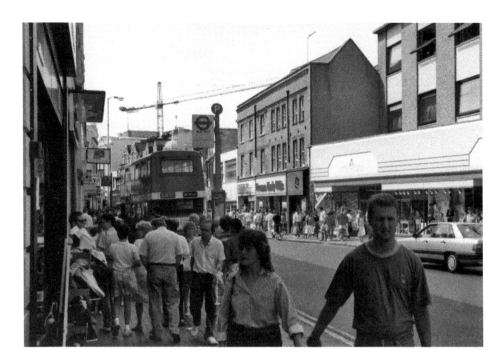

### Last Traffic Day

The last day of traffic in Clarence Street again, this time looking west, giving a good idea of how much pedestrianisation was needed. Freeman Hardy & Willis, the shoe shop, had been in Kingston since 1884 but only at this Clarence Street site since 1968. Pedestrianisation didn't help them and they closed in 1990. Littlewoods to the right was in Clarence Street from 1961 and was taken over by Marks & Spencer's in 1997. Originally the site of its menswear shop, this is now the location M&S.

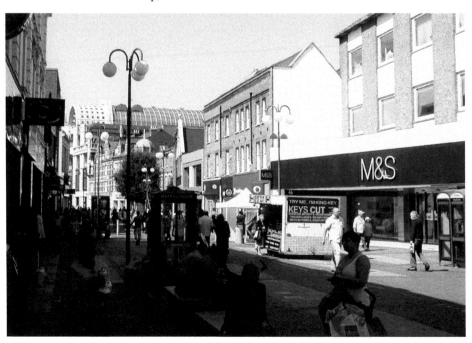

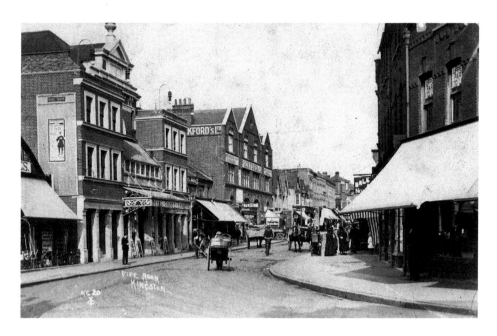

### Royal County Theatre

Fife Road in 1913 and today. On the left is the Royal County Theatre, Kingston's first purpose built theatre which opened in 1897. It closed as a theatre in 1912 following competition from The Empire which opened in 1910 in Richmond Road. After this it became a cinema, briefly a theatre again in 1915-1917, then a cinema until 1940 when it burnt to the ground on 9 February. Succeeded by Time Furniture Store and, later, Tower Records, it is now SportsDirect.

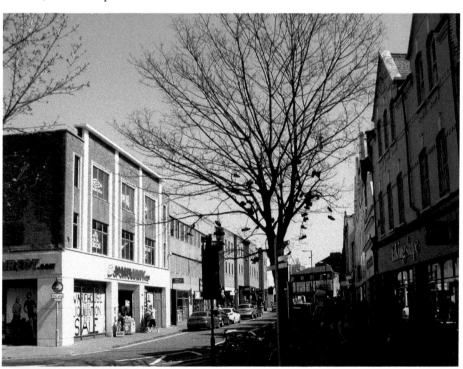

## The Changing Face of Fife Road

Another photograph of 1989 shows the shops of Fife Road from No. 66 to 58. Reading from left to right are The Record Shop, Atlas Employment Agency, Carpetview, Tyson Sewing Machines and a newsagent. The last shop, H. T. H. Fitted Kitchens is on the corner of Castle Street, now Two Seasons fashions. Twenty-five years since this photograph, only the newsagent remains. Almost out of picture on the right is the equally short-lived Surrey Building Society (1986-1990).

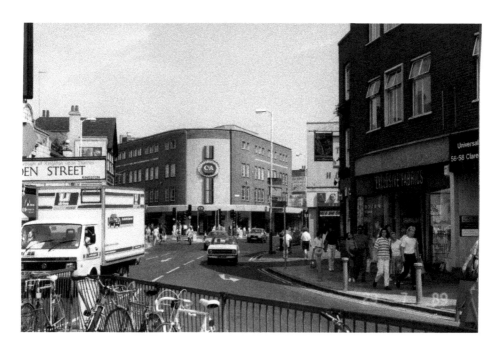

### The Site of the Elite Cinema

C & A was a major store in Kingston from 1956, when it replaced the Elite Cinema at a time when many cinemas were closing as more people watched television at home. Originally 19 London Road, in 1956 it was redesignated 146-152 Clarence Street. C&A was owned by the Brenninkmeyer family who lived locally and contributed to the building of St. Ann's Church, Kingston Hill amongst other charities. C&A folded in 1996 and the site was taken over by Wilkinson, who rebranded themselves as Wilko in 2012-13.

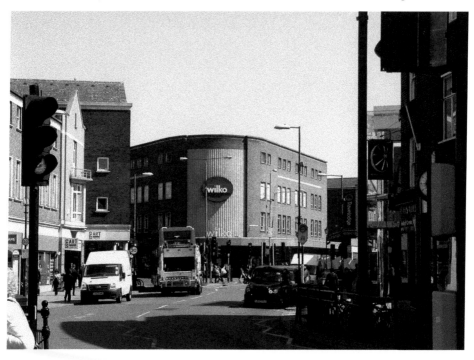

### The Mayor Opens Clarence Street

On 31 July 1989, the Mayor, Michael Mannall, officially opened Clarence Street to pedestrians only. The big Wimpy store is actually at the junction of Clarence and Eden Streets with the left hand part being 56 Clarence Street and the right hand part 90 Eden Street. Grand Metropolitan (Diageo) bought Wimpy in 1984 and Burger King in 1988 and redesignated all the fast food stores as Burger King. They sold them off in 2002. The Eden Street Burger King closed in 2007 and is now an HSBC bank.

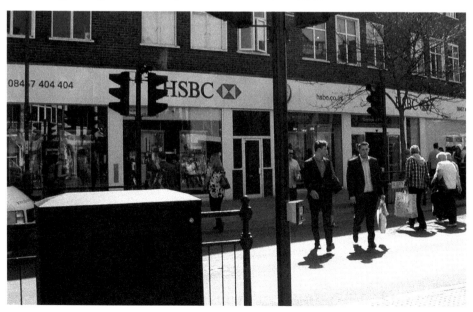

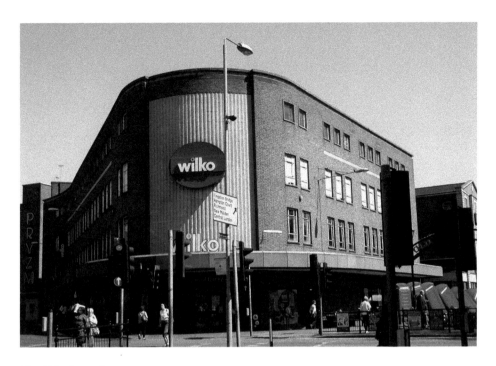

### The Telephone Boxes

Henry Shepherd ran a very successful fruiterer's business at 15 London Road from the late 1880s until 1903. In the 1890s he also had an establishment at 36 Thames Street. In 1908 he reappeared at 12 Mill Street where his business finally closed its doors in 1920. This site, along with 17 and 19 London Road were demolished to build the Elite Cinema. Shepherd's shop lay behind where the telephone boxes are today. The telephone box sculpture, 'Out of Order' was unveiled in 1990 and has become a popular landmark.

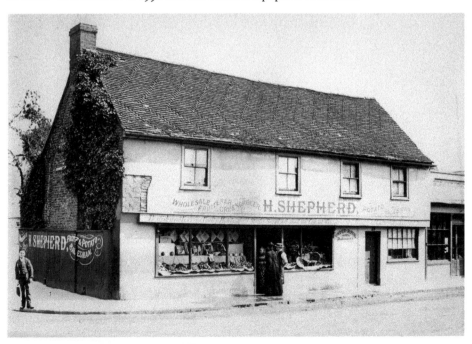

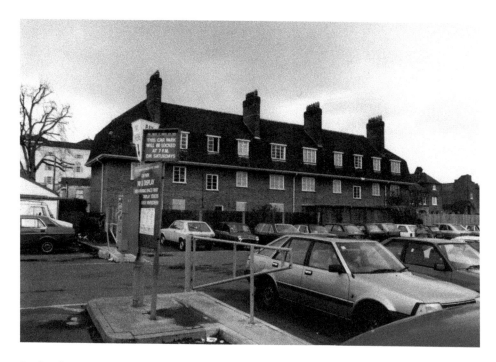

## Dryland House

Dryland House, showing Fairfield North and Bentalls depository behind, was a block of twelve flats built in 1952, probably to help with post-war housing, although private houses should not have been built on the Fairfield which has long been designated for leisure use only. The photograph shows them just prior to demolition in the early 1980s. The site is now reincorporated into the Cattle Market car park and bus station.

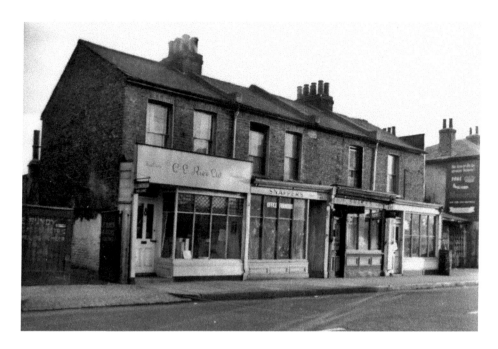

### Snapper's Kingdom

A view of London Road which took me a long time to trace when and where. This was taken in the 1960s by Les Kirkin, who took photographs for Kingston Museum for many years, and after whom Kingston Museum's annual photography prize is named. The C. E. Rice Co. were decorators who left 154 London Road in *c.* 1960. At the time of the above photo Michael Snapper owned much of this block as well as 'Snapper's Castle' opposite (now Wickes). He was a well-known junk and antique dealer.

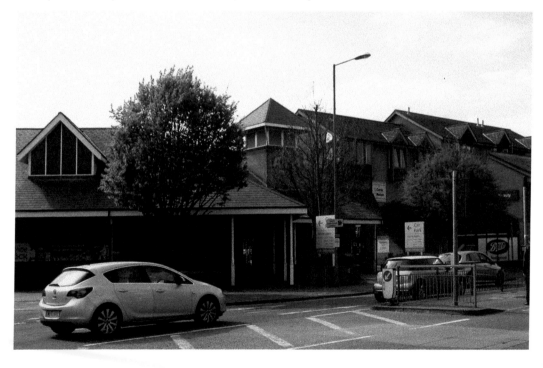

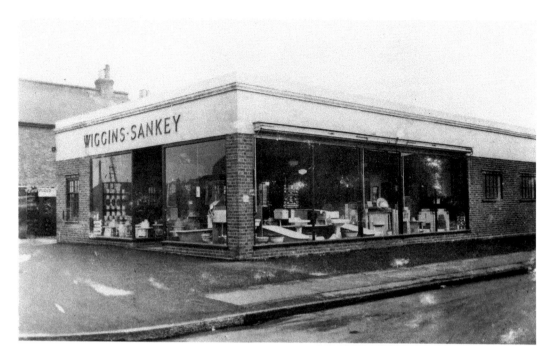

## Cromwell Road Bus Stops

Wiggins and Co. were in Kingston from the late 1880s. They joined up with Sankey in the 1920s and were builders merchants dealing in slate, lime and, especially, coal. They were in Railway Wharf, which is the north side of Cromwell Road opposite the junction with Hardman Road. In 1940 when they were last listed, the other four traders on Railway Wharf also dealt in coal. They were replaced by Epheta Chemical Bottle Manufacturers.

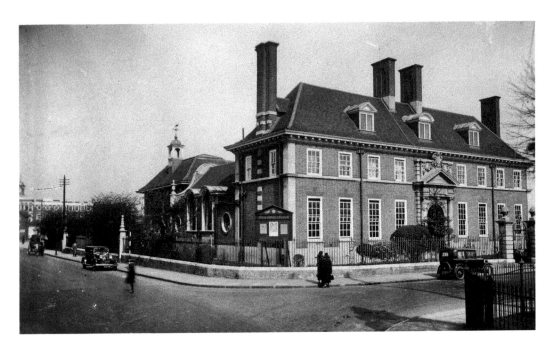

### Carnegie's Gift

Kingston Library opened in 1903 thanks to a generous donation from Andrew Carnegie, who paid for so many public libraries in this country and elsewhere. He enjoyed his reception at the opening in Kingston so much that he gave a further £2,000 so that the Museum & Art Gallery could also be built. That opened in 1904. The road layout has changed since, Fairfield West becoming Wheatfield Way, but the buildings are fundamentally the same.

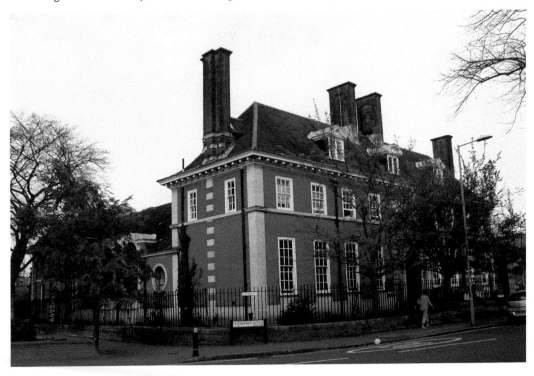

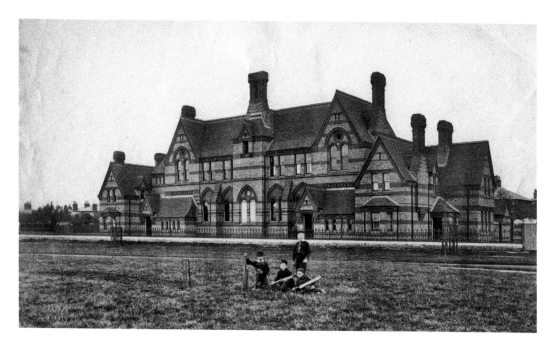

## From Tiffin to St. Joseph

In 1638 and 1639, two brothers, Thomas and John Tiffin, left money in their wills to educate children of the 'honest poor'. This money was used to buy land, the rent from which paid for the education. In 1880 some land was sold and Tiffin School for boys and girls was built on the Fairfield. The girls moved out in 1899 to St James' Road, and the boys' school moved to the London Road in 1929. Today the school buildings are used by St Joseph's Catholic Primary.

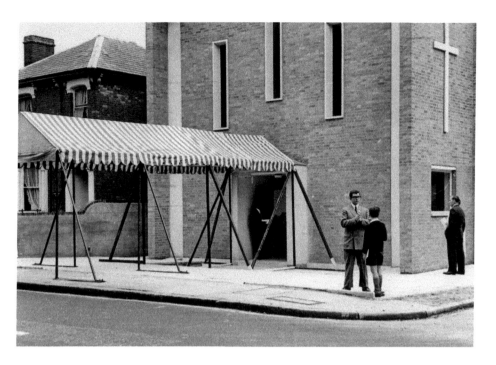

## Opening the New Methodist Church

The official opening of Kingston Methodist Church in Fairfield South took place on 16 July 1966. It was opened by the Revd Douglas Thompson, President of the Methodist Conference, with a dedication ceremony by the Revd Cyril Wainwright, Chairman of the South West London District. The Revd Ernest Tansley, the Fairfield South minister, conducted the service for a congregation of about 400.

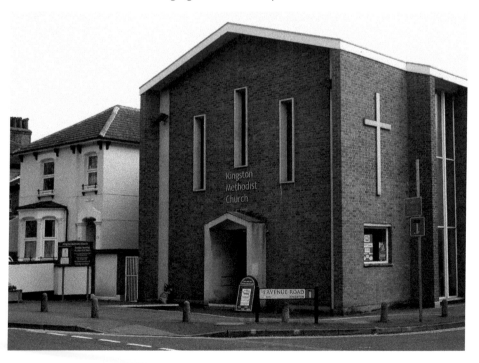

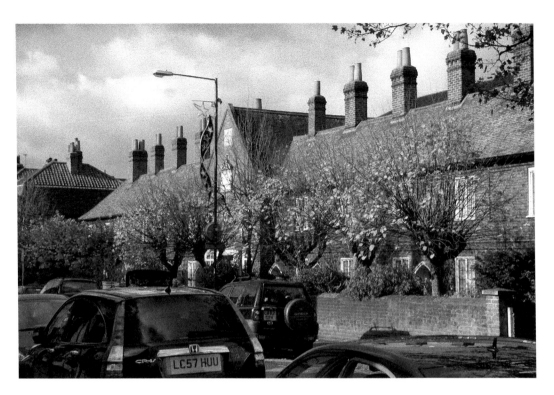

### For the Poor of Kingston

Cleave's Almshouses were built in 1669 after William Cleave left money in his will for the erection of a house for 'six poor men and six poor women of honest life and reputation'. They were extended in 1889 to accommodate six married couples as well, and refurbished in 1994. One of its most interesting inhabitants was Eric Pountney in the 1970s, a founder member of the Communist Party of Great Britain back in 1919.

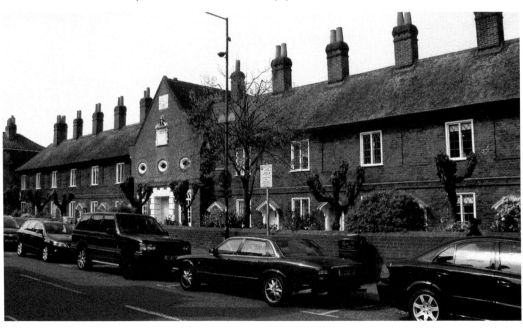

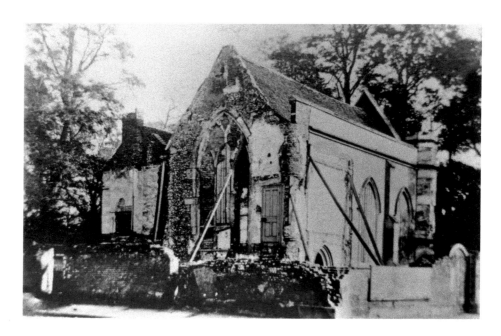

### Lovekyn's Chantry Chapel

The Chapel of St Mary Magdalene, more informally known as the Lovekyn Chapel, was built in the fourteenth century by Edward Lovekyn as a chantry chapel, where a priest would pray for the souls of the Lovekyn family. Closed under Henry VIII, it reopened in 1561 as the Queen Elizabeth Grammar School (now Kingston Grammar School) and was indeed the school's only building until 1878. Close to being demolished in 1885 (see above photo!), it was saved and is now a much-loved part of the school.

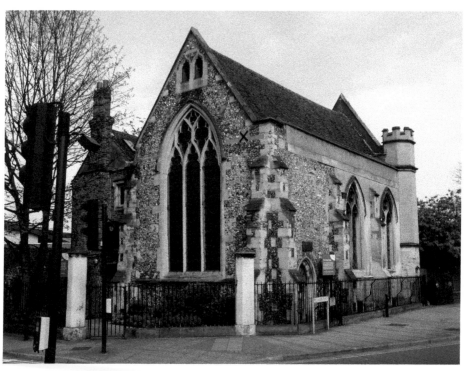

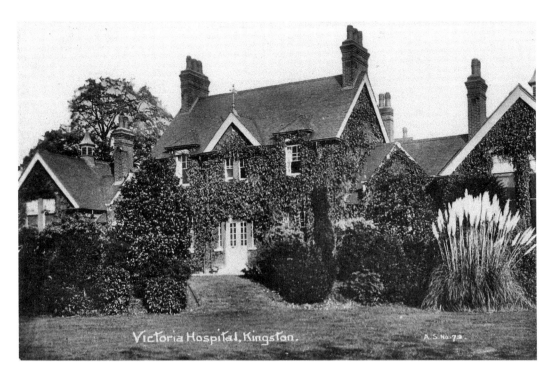

Victoria Hospital, Kingston.

A.S. No. 72

## The Victoria Hospital

The Victoria Hospital was Kingston's first proper hospital, opened in 1898 after fund-raising to commemorate Victoria's Diamond Jubilee the previous year. Built in Coombe Road opposite the Workhouse, which is now Kingston Hospital, it later became the Eye Unit for that hospital before being demolished to make way for retirement homes.

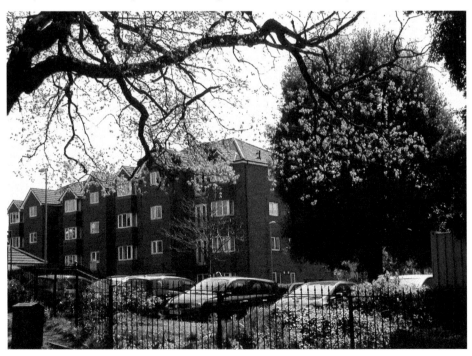

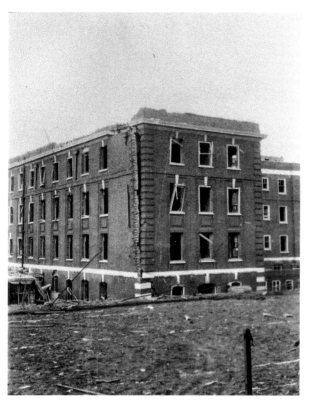

## Bombs over Kingston

This is one of only a handful of bomb damage photographs which exist for Kingston. It shows the results of a V1 Flying Bomb (Doodlebug) attack on Thursday, 5 July 1944. This was the Casualty Ward of Kingston Hospital and two people were killed, a nurse and a cleaner. Recently the building housed psychiatrists and social services, but it is currently awaiting a change of use. It is impossible to photograph the building from exactly the same spot due to later hospital buildings.

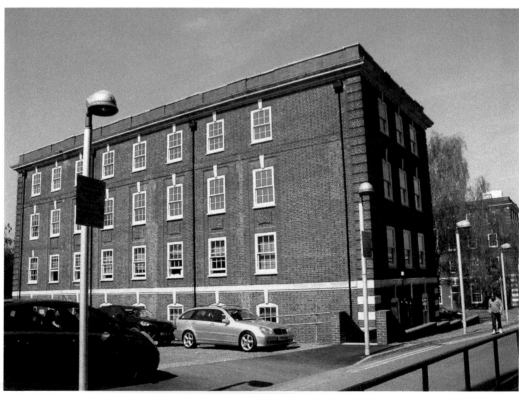

## A New Church for Kingston

St Peter's church in Norbiton was the first new church to be built in Kingston proper to cope with the growing Victorian population, opening its doors in 1842. Churches had already opened in the outlying districts of Ham, Hook and Kingston Vale in the 1830s. The clock was put in the tower in 1866 but there has been little change since.

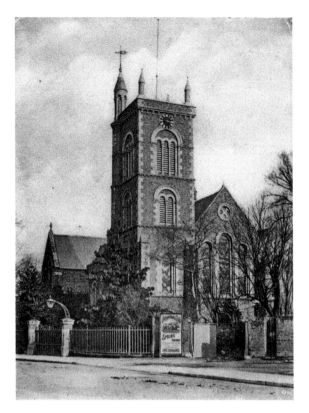

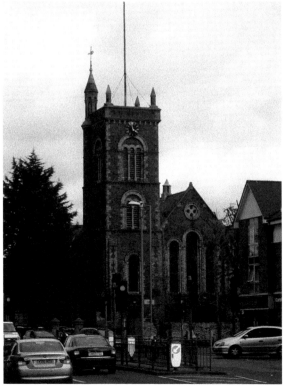

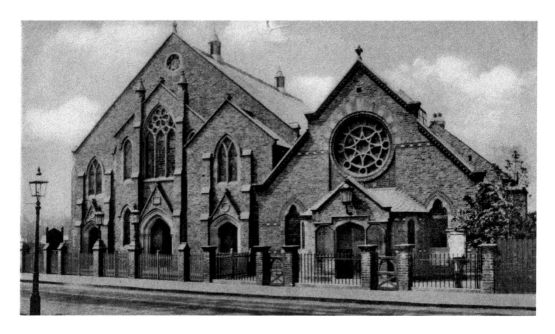

## A Vanished Beauty

The John Bunyan Baptist Church and its associated Kaleidoscope Centre stand in Queen Elizabeth Road, on the corner of Cromwell Road. The original chapel was built by a group breaking away from the Union Street Baptist Chapel. They opened their new chapel, seating 300, in 1885. It was enlarged in 1891 and 1894. In the 1960s, the new minister Eric Blakeborough developed a youth ministry, which developed into a specialised centre to help those with drug and alcohol problems. The old chapel was demolished in the 1970s and replaced with a smaller chapel and the Kaleidoscope Centre with a hostel for forty. Kaleidoscope closed in 2013, and a nursery currently occupies part of the building.

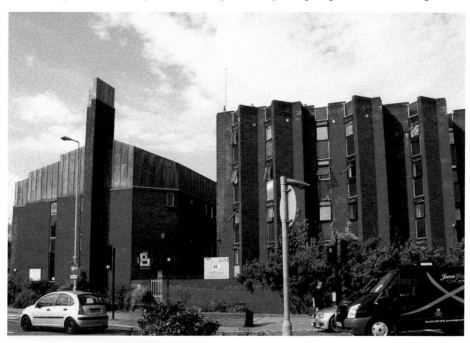

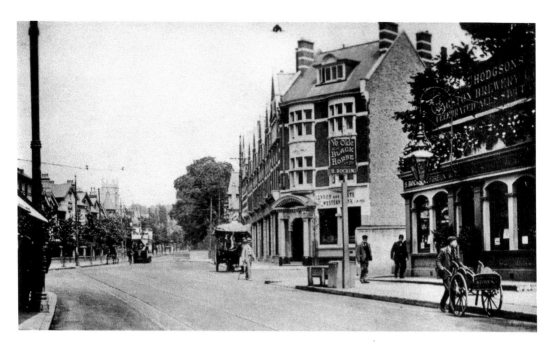

**Where did that traffic come from?**

Kingston Hill in about 1910, looking north from London Road, with Manorgate Road on the right. In the distance is a tram and the Wesleyan church. The Old Black Horse is at 204 London Road. It was founded in *c.* 1840 and changed its name to the Kingston Gate in 1999. The bank on the far corner is at 2 Kingston Hill and was the London and South Western Bank, which became Barclays in 1917.

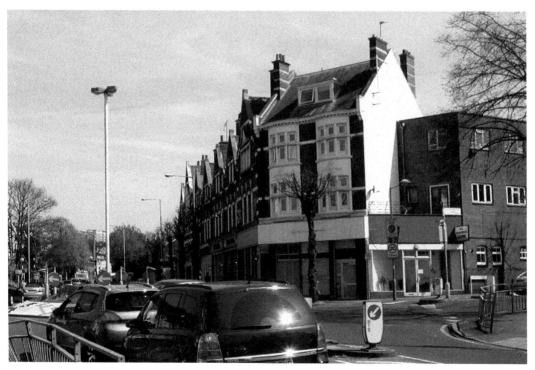

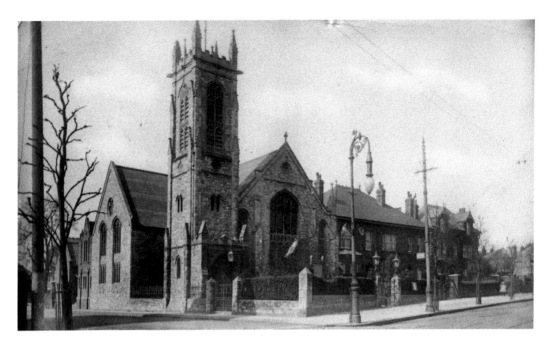

## Another Vanished Beauty

A growing population and the spread of Methodism led to the founding of a Wesleyan Methodist church on Kingston Hill in 1879. An initial temporary corrugated iron church was replaced in 1886 by the brick built chapel shown above. In 1932 the Wesleyan and Primitive Methodists united and, with a fall in congregation numbers, this church closed in 1958. After demolition, it was replaced by Argosy House which housed NHS offices for Kingston Hospital until recently. It is now empty.

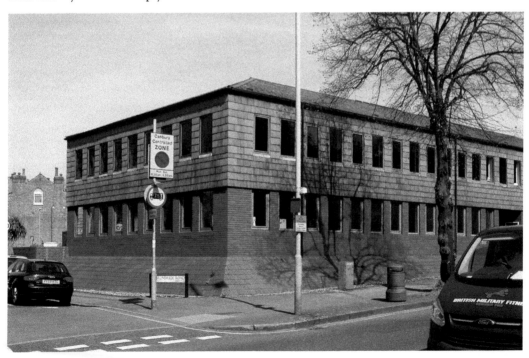

## The Princess Louise Home

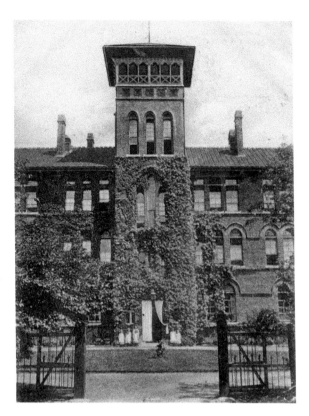

Built in 1875 as the Metropolitan Convalescent Institution (for sick children), this imposing building was bought in 1892 by The National Society for the Protection of Young Girls, and renamed The Princess Louise Home after their patron. They saved deprived girls from falling into prostitution, and trained them principally for domestic service. In 1933 it was sold again and became a Barnardo's home for boys. This closed in 1968 and was demolished shortly after. It is now the site of Blenheim Gardens.

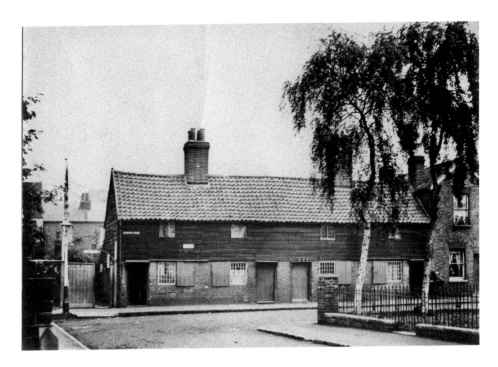

### Let Me Through to the Pub!

This is the corner of Church Road and Albert Road in Norbiton photographed in about 1900. In the 1920s an alleyway was pushed through to the London Road so that people could reach the Three Tuns Public House. More houses were demolished in the 1950s and Albert Road was extended through to the London Road. After short spells in the 1990s as The Flamingo & Firkin and The Hog & Stump, the old Three Tuns became The Tup in 1998. It was renamed as No. 88 in 2009 and became The Old Moot House in 2014.

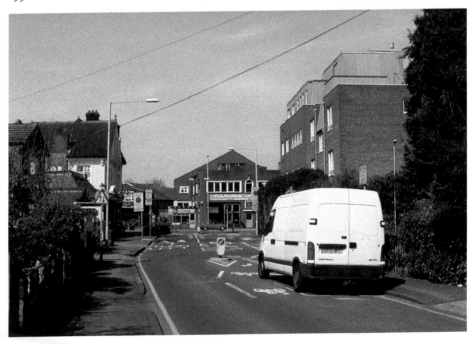

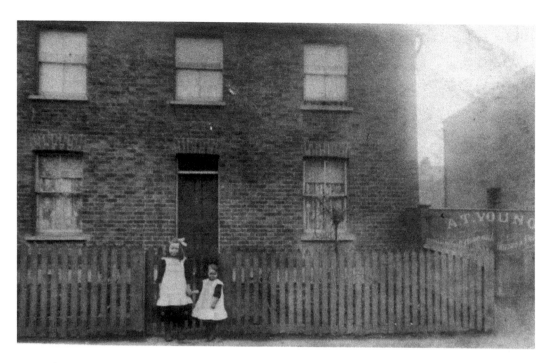

### The Victorian Poor

These two girls are Nellie Parker and her friend Maisie Parkin, standing outside Nellie's house at 22 Burritt Road. Nellie's father, Henry, was a fishmonger from 1914 to 1932. After he died, Nellie's brother, Henry Walter Parker set up a short-lived crazy paving venture. These houses were demolished in the 1960s to make way for Shelford House, part of the Cambridge Road estate.

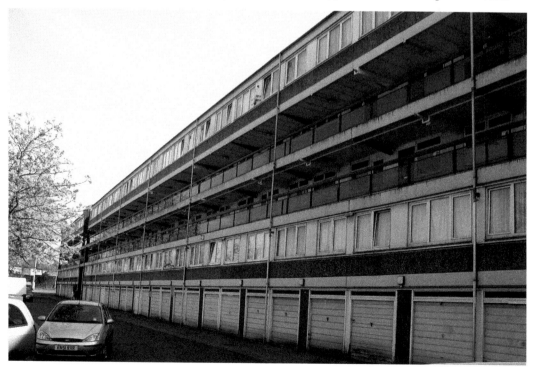

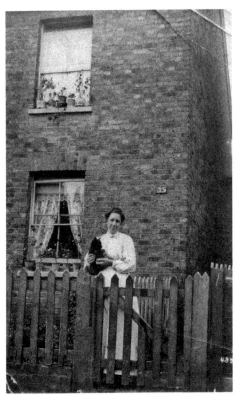

### Change for the Better?

Annie Ditchet stands at the gate of 39 Burritt Road with her cat although, according to street directories, this was actually the home of Mr Creswell, a wall-paper hanger. Perhaps she was visiting. Burritt Road has been transformed by the erection of the blocks of the Cambridge Road Estate. This was an admirable attempt to improve housing in the area, although the tower blocks are not as admired now as they were in the 1960s and 1970s.

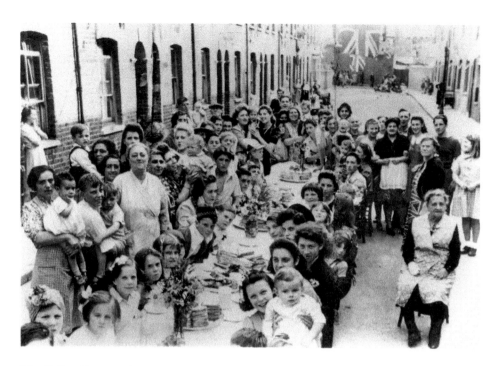

### The Italian Community

Asylum Road in Norbiton was named after the nearby Cambridge Road Asylum, but the residents objected as 'asylum' became more associated with madness rather than illness, and the name was changed to St Peter's Road in 1948. This road was the centre for the large Italian community in Kingston and there were protests against the people living here, including a brick thrown through a window, when Italy entered the war against Britain in June 1940. This puts the celebration of VE Day shown above in a somewhat different context.

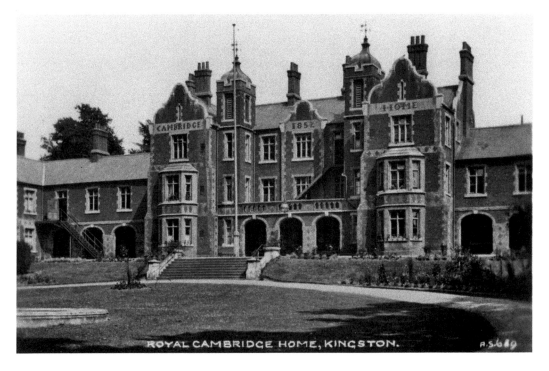

ROYAL CAMBRIDGE HOME, KINGSTON.

## Royal Cambridge Home

The Royal Cambridge Home, or Asylum, in Cambridge Road was built in 1852 as a home for widows of NCOs and privates of Her Majesty's armed forces. The land was given by the Duke of Cambridge, hence the name. It was destroyed by a V1 flying bomb in 1944 which killed two widows. The widows removed to a house in Long Ditton and this block of 160 flats, Cambridge Gardens, opened on the site in 1949.

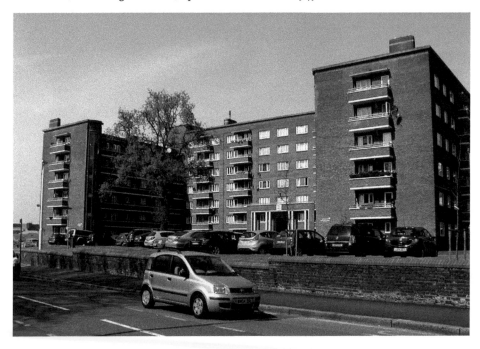

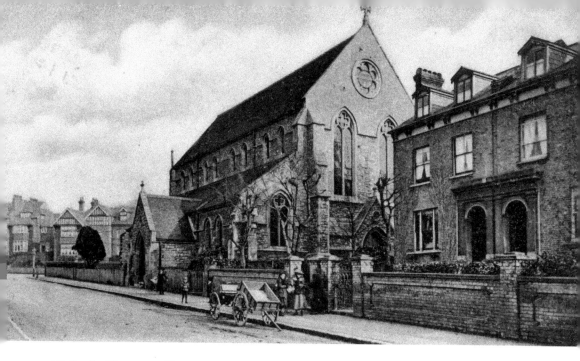

### St. Paul's, Kingston Hill

St. Paul's church, on the corner of Queen's Road and Alexandra Road, was built in 1876-7, replacing an earlier temporary church made of corrugated iron. The Bishop of Guildford formerly opened the church in 1877, but it was not consecrated until 1880, after the debt for building had been paid off. Since then, a chancel and ambulatory have been built (1911-2) and south and north transepts (1924 and 1928). The cross on the roof possibly fell off when a V2 rocket landed nearby in January 1945. The Victorian houses on the right were pulled down in the 1950s.

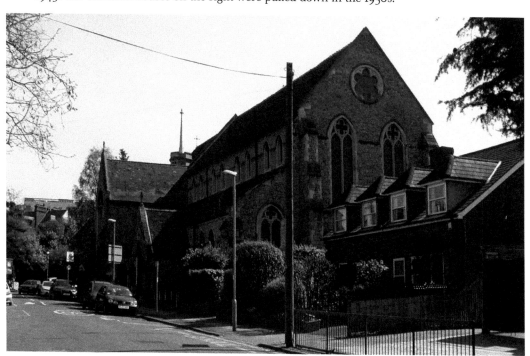

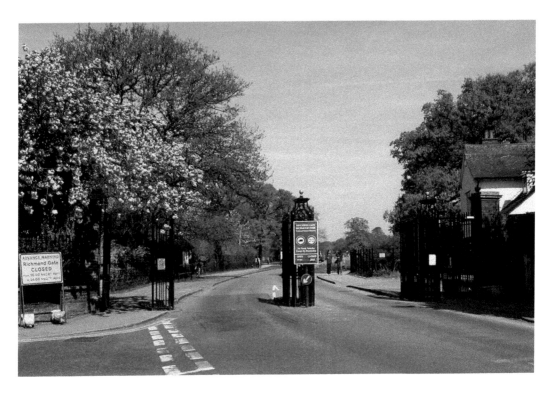

## Kingston Gate

Until recently, this corner of Richmond Park lay within the Borough of Kingston, but the whole park now lies within Richmond. The Park was laid out in 1638 by Charles I as a place to hunt deer, against the wishes of many local people. Oliver Cromwell gave the park to the citizens of London, and although it reverted to Royal ownership, the public have been welcomed for over 200 years now.

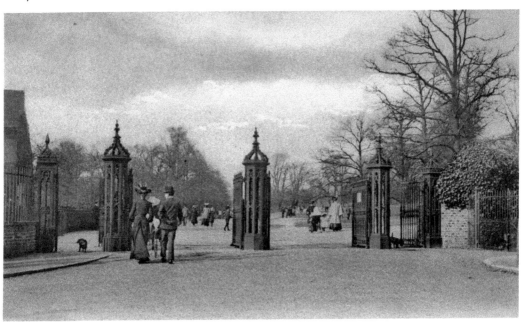

### St. Agatha's

St Agatha's Roman Catholic church was opened in 1898 as the first Catholic church in Kingston, although St. Raphael's had existed in Surbiton since the 1850s. It was built near the barracks in Kings Road, and Irish soldiers and their wives helped fill the congregation. A major benefactor was Mrs Caroline Currie who also contributed heavily to the Sacred Heart church in Wimbledon. The only major change that has been made is that the pulpit (seen on the left in the first photograph) has been sawn in half to make the two ambos in front of the lecterns on the altar today. This was done in the late twentieth century.

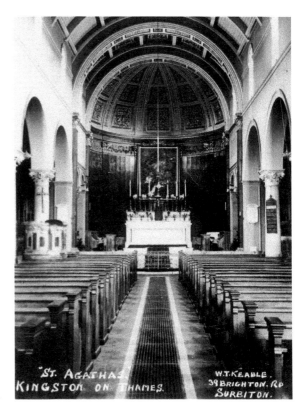

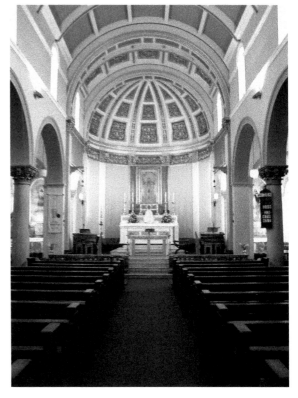

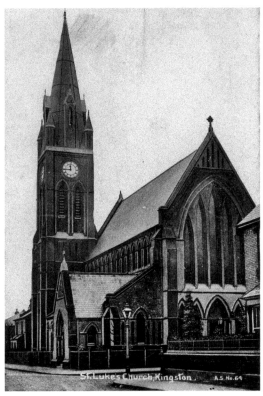

### St. Luke's

St Luke's church stands at the junction of Gibbon Road and Burton Road in north Kingston, and was opened in 1889 to serve the Canbury area. Lady Wolverton, who had helped contribute, had had great difficulty in finding the church on opening day, so in 1891 she paid for the tall spire so that she might not get lost again! The clock in the tower was also a godsend in a poor district where most people did not have watches.

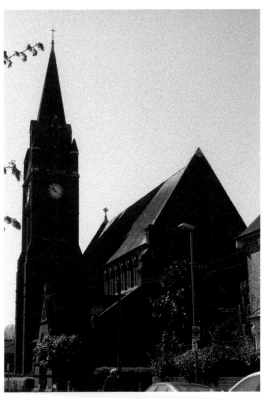

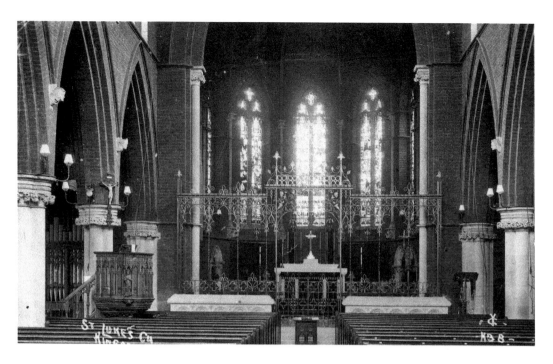

## A Gothic Interior

St Luke's is a brick built church, built by Gaze's of Kingston from Claygate bricks in the Gothic style of most Victorian churches. It is well known today for its high Anglo-Catholic services, beautiful statues, and pilgrimages to Walsingham. In the 1990s the church was without a priest for a while, since the congregation refused to accept a woman priest.

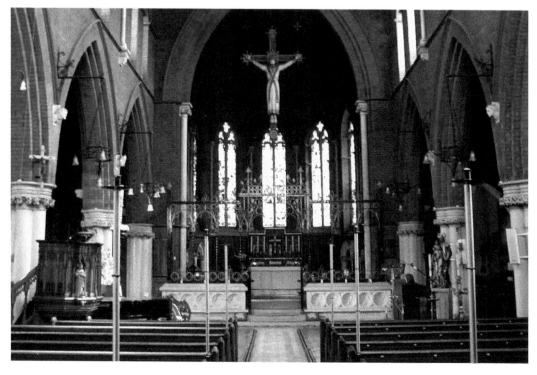

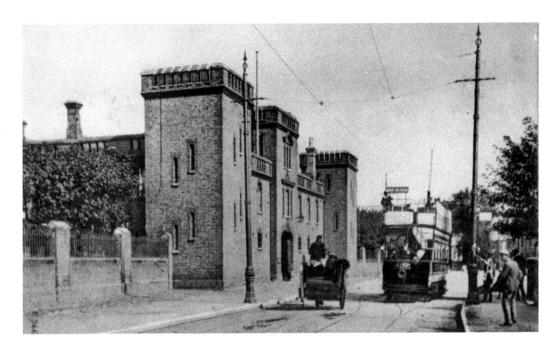

### East Surrey Regiment Barracks

Army reforms in the 1870s and 1880s led to the renaming of regiments and the building of barracks in towns to encourage recruitment. The barracks in Kings Road became home to the East Surrey Regiment from 1884 until 1959 when the regiment was amalgamated for the first time. There have been many regimental changes since. The barracks were demolished and replaced with housing, but the imposing keep was kept as quarters for army officers. It was renovated in 2010 and is now private apartments. The building is currently undergoing much-needed repairs.

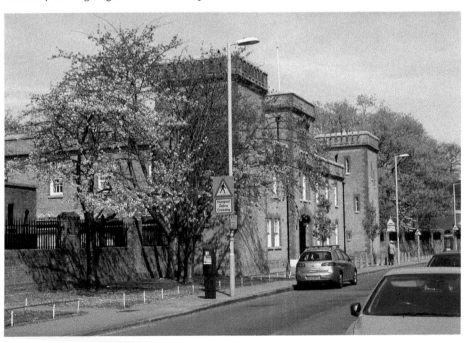

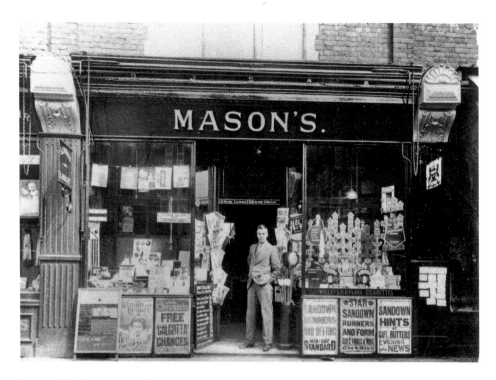

## A Long-lived Newsagent's

150 Richmond Road was a sweet shop and newsagent almost from the time it was built, certainly from 1902. The proud owner in the doorway in the top photo is George H. Mason who gave his name to the shop in 1940. He was succeeded by his son and then by other owners who kept the Mason's name until about 1980. Still a newsagent's, it is now known as Jay's.

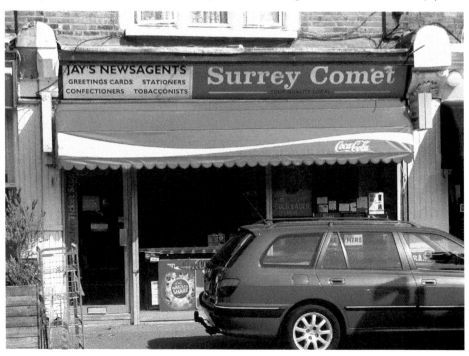

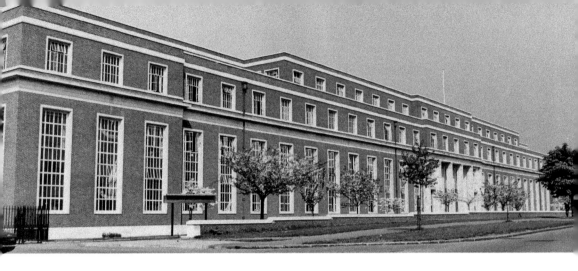

## Aeroplanes in Kingston

Kingston was famous for building aeroplanes since before the First World War when Tommy Sopwith opened his first factory in Canbury Park Road. After the First World War the firm became Hawkers and built the famous Hurricanes in the Second World War, although this Richmond Road site was leased out at the time to Leyland to build tanks. The frontage was erected in the 1950s. The last aeroplanes built here were Harrier Jump Jets. The factory closed in 1992 and has been replaced with housing.

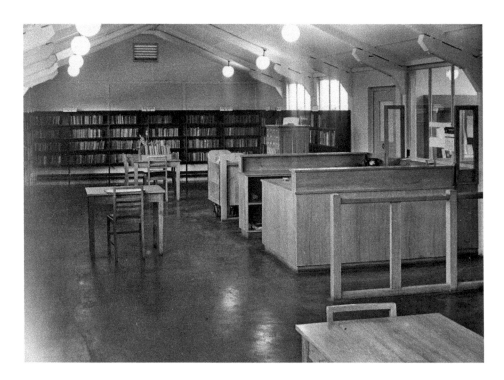

## Tudor Drive Library

Tudor Drive Library was first planned in 1936 but, thanks to the Second World War, it was not built until 1951. It was opened by Mayor Sinclair and consisted of a community hall to seat 170 as well as a library for 5,000 books. In recent years it has been threatened with closure many times, but its loyal members have always stepped in to save it.

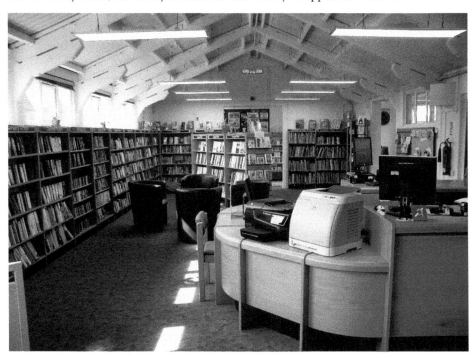

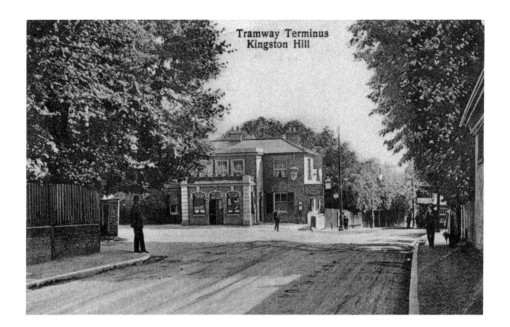

Tramway Terminus
Kingston Hill

### Highwayman Hill

An inn has stood on this site at the junction of Kingston Hill and George Road since before 1708 when it was known as the Fox and Coneys (Rabbits). In 1760 when George Road was laid out, it was renamed the George, and in 1828 became the George and Dragon. It was a sign of welcome to Kingston for travellers who had braved the highwayman-infested road from London. As the postcard says, from 1906 to 1931, this was also the place where the trams began and ended. A plan to push the tracks right along the Richmond Park boundary to Putney never happened. The George and Dragon was renamed The Kingston Lodge Hotel in 1985.

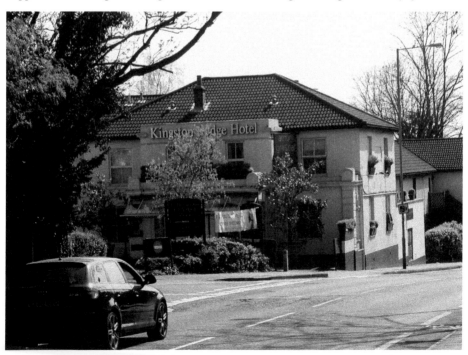

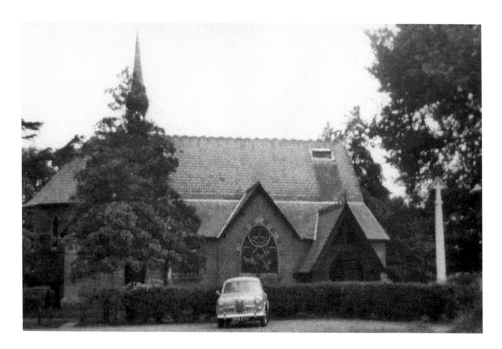

## St John's, Kingston Vale

The first St John's church in Kingston Vale was a chapel built in 1847 and served by the vicar of Ham. As the congregation grew, this church was built in 1861 on land given by the Duke of Cambridge. The Duchess of Teck, later Queen Mary (wife of George V) was a regular worshipper here before her marriage. The top photograph was taken on the occasion of its centenary in 1961. The tree in front has grown a lot since then, necessitating a picture from a different angle.

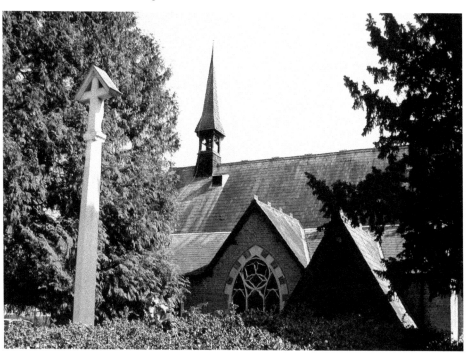

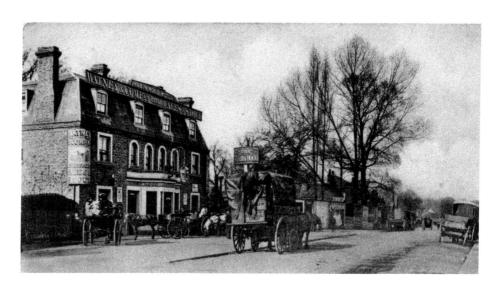

### Robin Hood Inn

In medieval times there were May Games held in Kingston which sometimes featured the characters of Robin Hood, Maid Marion and the rest. It is uncertain if this is related at all to a place in the Richmond Park area (but before the park was laid out by Charles I) being named Robin Hood's Walk in the 1540s. Subsequently there was a farm called Robin Hood's Farm, and the name is now attached to many streets and buildings in the area of Kingston Vale. The Robin Hood Inn shown here opened in 1870 to serve travellers who now race past on the A3. Since they no longer stopped, the Robin Hood closed in 2002 and became the Robin Hood Well Being Centre, offering 'alternative' treatments such as massage and aromatherapy. This recently closed and the building is now private apartments.'

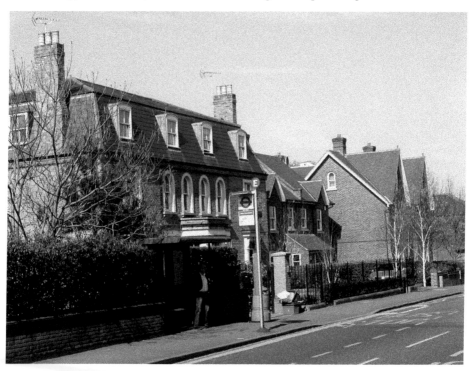

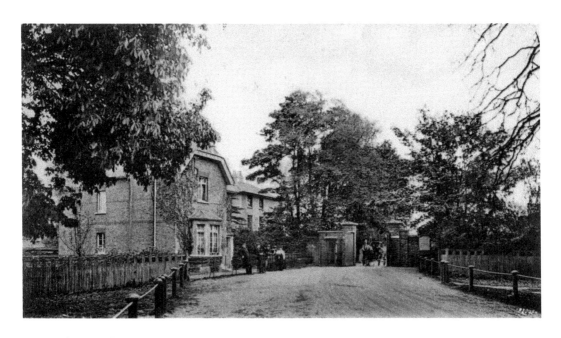

### Robin Hood Gate

Robin Hood Gate was named after Robin Hood Farm, not Robin Hood Inn as is frequently stated, in the eighteenth century. On the earliest maps it is called Wimbledon Gate. The top photograph shows the gate just before it was widened for vehicles in 1907. The gate opens directly onto the A3, and this was the cause of many hold-ups and accidents. The gate is now only open to pedestrians and horses.

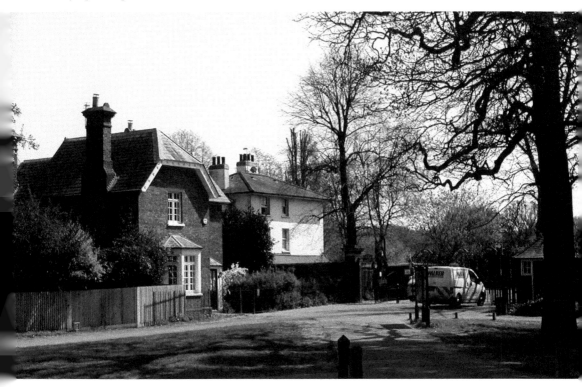

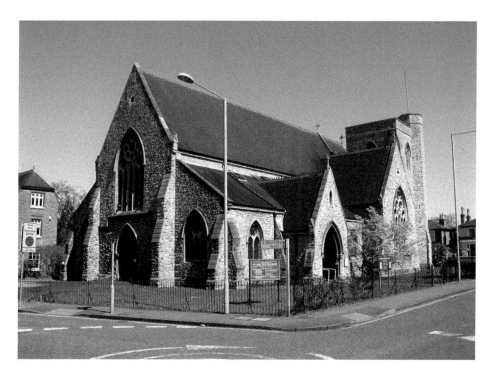

## St John the Evangelist, Spring Grove

Spring Grove, to the south of Kingston Town, was a Victorian housing development of the 1860s. A temporary iron church was built in 1870 but the following year the foundation stone for a new stone church was laid by the Bishop of Winchester. It was called St John the Evangelist and opened in 1872. The tower was finally added in 1935 but a proposed spire never materialised. In the 1970s, the church was threatened with closure due to a small congregation and high maintenance costs, and in 1976 the parish was amalgamated with All Saints. It now has a part-time priest in charge rather than a vicar.

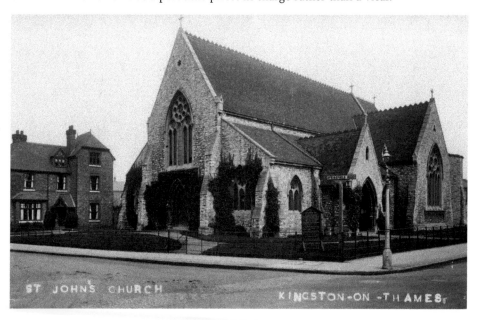

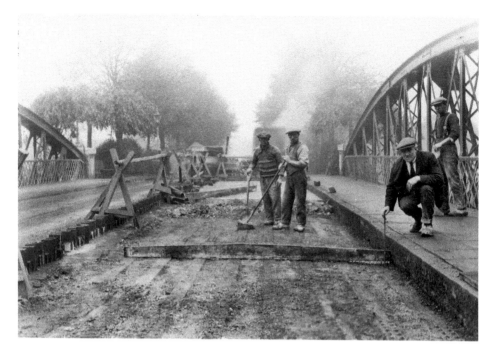

### Will It, Won't It Bridge

Knights Park Bridge over the Hogsmill was opened in February 1894 to help connect Surbiton and Kingston. It is shown above undergoing repairs in the 1950s and was closed to traffic in 1990 with severe structural problems. For a long while it was known as the Will It, Won't It Bridge, since the council dithered over repairs. It was finally reopened in 1993 in time for its centenary and, although it can take vehicles, the road is no longer a through road to Surbiton and the traffic is much reduced.

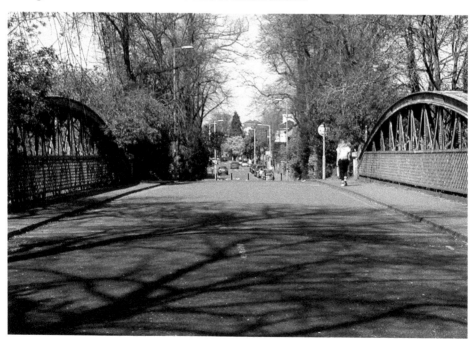

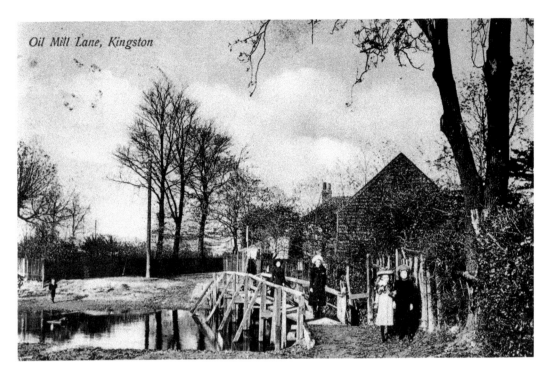

*Oil Mill Lane, Kingston*

### Villiers Road Bridge

Villiers Road was known as Oil Mill Lane when the top photograph was taken. Oil Mill on the Hogsmill River had produced linseed oil until the 1880s, and the road took its name from there. It was given the more romantic name of Villiers Road in 1924 after Lord Villiers who was killed nearby at the Battle of Surbiton in 1648 in the English Civil War.

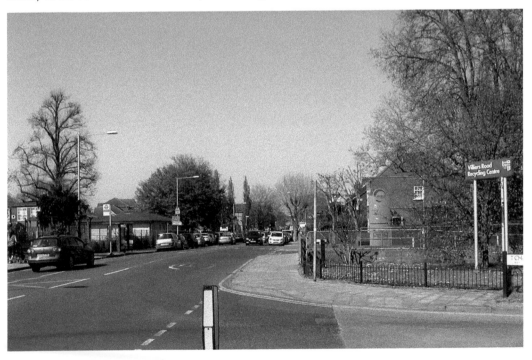

**Victoria Road Chapel**
The Primitive
Methodist chapel
in Victoria Road,
Norbiton, was built
in 1866. It replaced
the Ebenezer chapel
which had been a
Strict Baptist chapel.
In 1963 the Methodists
decided to build a new
church at the corner
of Fairfield Road and
Avenue Road and the
Victoria Road chapel
was sold off in 1966.
It was bought by
Kingston Polytechnic
and now belongs to
Kingston University.

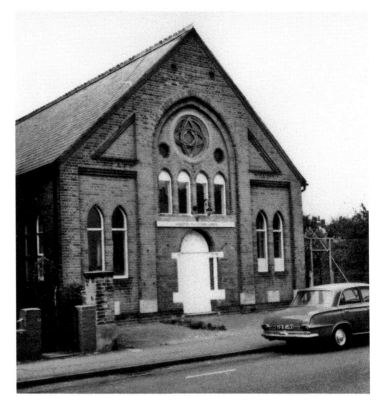

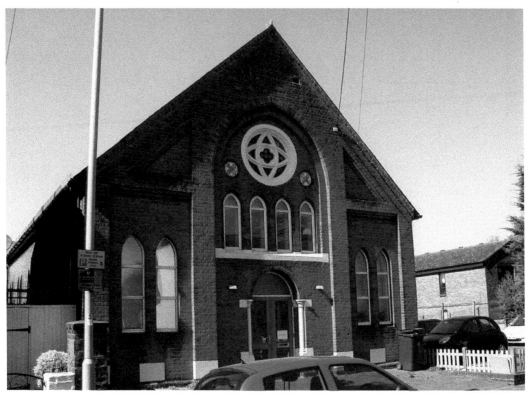

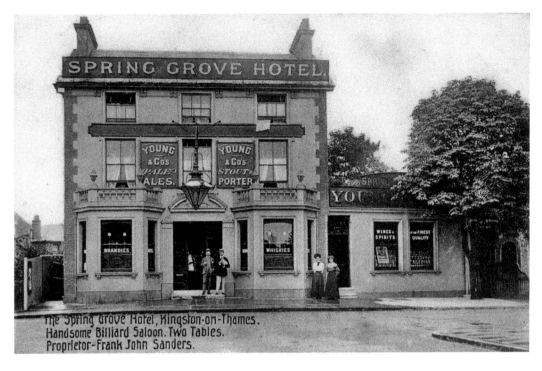

The Spring Grove Hotel, Kingston-on-Thames.
Handsome Billiard Saloon. Two Tables.
Proprietor-Frank John Sanders.

### Spring Grove

The Spring Grove Hotel in Bloomfield Road opened in 1867 and is still going strong. Many of its Victorian landlords/proprietors only lasted a couple of years in post, but Frank John Sanders made a real go of it, issuing these advertising postcards. He was the proprietor from 1908 until about 1917. It still serves beers from Young's Brewery.

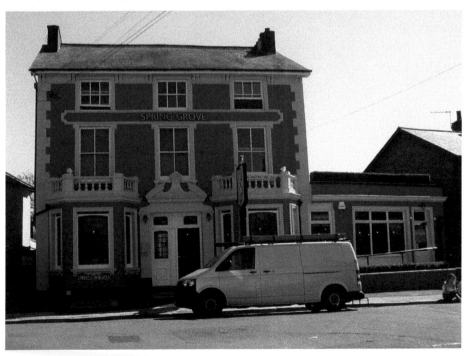

## Empty Corner

This is 41 Portland Road, originally Surrey Cottage. The earliest reference to this property is 1894, when it was lived in by James Steed, carpenter, with his wife, daughter and four lodgers. In 1905 it became a fish and chip shop under Mr Di Rosa and Mr Hughes and remained a fish and chip shop (apart from a short stint as a greengrocer's) until 1970 when the top picture was taken. J. B. Birch had run the shop since the war. Since then it appears to have had a brief spell as a very small park, and is now derelict.

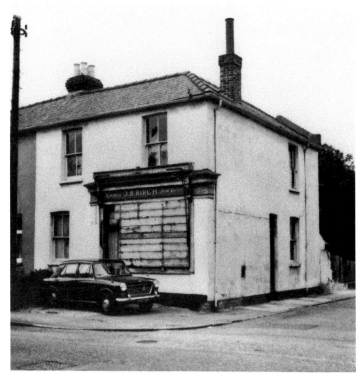

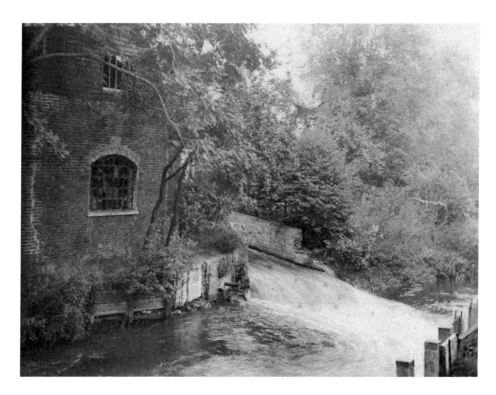

### The Tranquil Hogsmill

This is Marsh Mill on the Hogsmill River photographed in about 1920 after it had become derelict. Previously it was Hogs Mill from where the river took its name, sometime in the twelfth century. The Marsh Brothers had made high quality flour here from the 1870s. From 1896 until 1910 it produced 'Yewsabit' metal polish. It is now a quiet corner on the Hogsmill Walk where you can see herons if you are lucky.

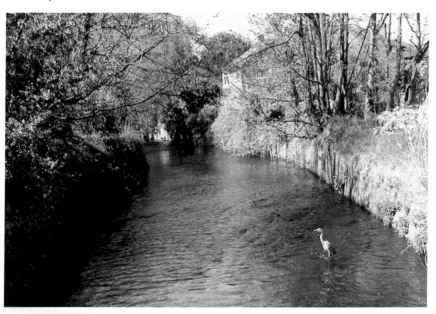

## The Water Splash

Looking north towards Brook Street, the Water Splash through the Hogsmill is quite deep in the top picture and seems barely fordable. The Splash was removed only in 1935-6 when the new Guildhall was built and the lower Hogsmill was all neatly canalised. Today the whole site has been transformed by Wheatfield Way and College Roundabout. It is hard to remember that the Hogsmill still flows under all this. The sculpture called 'Paper Trail' consists of fifty-seven 'paper' aeroplanes and celebrates the history of aircraft construction in Kingston. It was designed by Michael Antrobus and Tom Kean of Kingston University and unveiled in 2012.

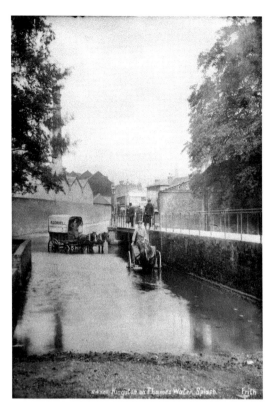

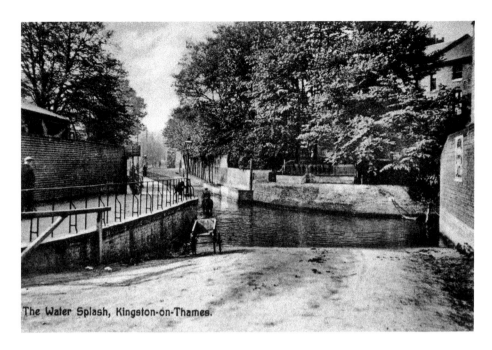

The Water Splash, Kingston-on-Thames.

### Water Splash looking south

This is the Water Splash at the southern end of Brook Street looking down Penrhyn Road. The Hogsmill River runs to the south of the Market Place and is crossed by the High Street at Clattern Bridge, but as Kingston grew, a further crossing was needed to the west where Brook Street met Penrhyn Road, and this vehicular ford and footbridge was constructed in Victorian times.

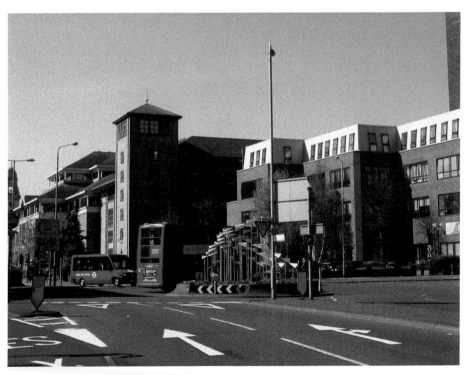

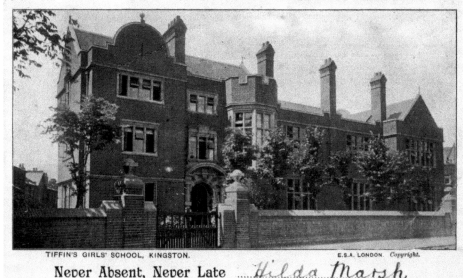

TIFFIN'S GIRLS' SCHOOL, KINGSTON.                    E.S.A. LONDON. *Copyright.*

Never Absent, Never Late ....*Hilda Marsh*....

### Tiffin Girls' School

There is a large series of 'Never Absent, Never Late, postcards awarded to school children in Surrey, although recent research dates them all to 1905. This example shows Tiffin Girls' School which opened in St James's Road in 1899, but moved to Richmond Road in 1937. The buildings were then occupied by Kingston Technical College until pulled down and replaced in the 1960s by the current building, part of Kingston College, formerly Kingston College of Further Education.

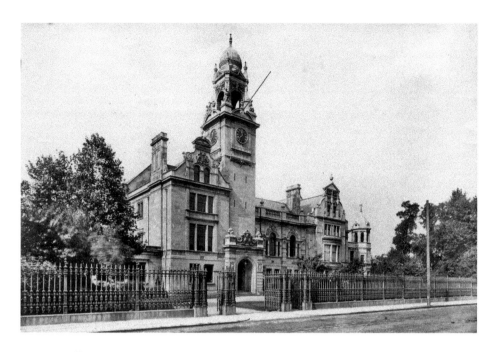

### County Hall

When County Councils were set up in 1889, Surrey voted to build County Hall in Kingston rather than Guildford and it is shown above in 1906. In 1965, The Royal Borough of Kingston-upon-Thames left Surrey to become a London borough and, consequently, Surrey is the only county whose administrative offices no longer lie within the county they administer! Attempts have been made by the County Council to relocate to Guildford (in the 1970s) and Woking (in the 1990s) but without success.

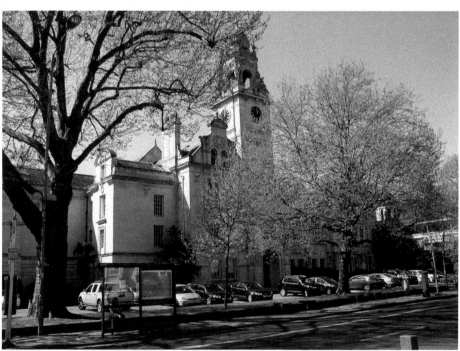

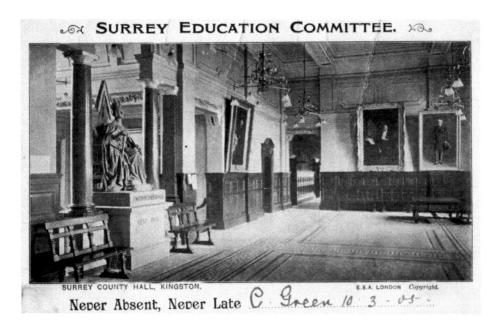

SURREY COUNTY HALL, KINGSTON.

E.S.A. LONDON *Copyright.*

Never Absent, Never Late *C. Green 10. 3 - 05 -*

### Inside County Hall

This is the Grand Hall on the first floor of County Hall featured on another 'Never Absent, Never Late' card. The statue of Queen Victoria at her coronation was unveiled in 1904 as a memorial to the Queen who died in 1901. It was modelled by Mr John Adams Acton and executed in terracotta by Doulton and Co. Unfortunately, it was badly damaged when County Hall was bombed in the Second World War and has been removed.

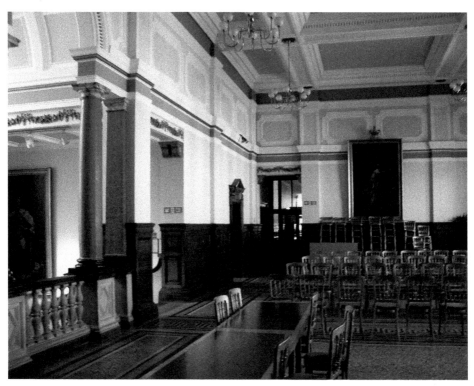

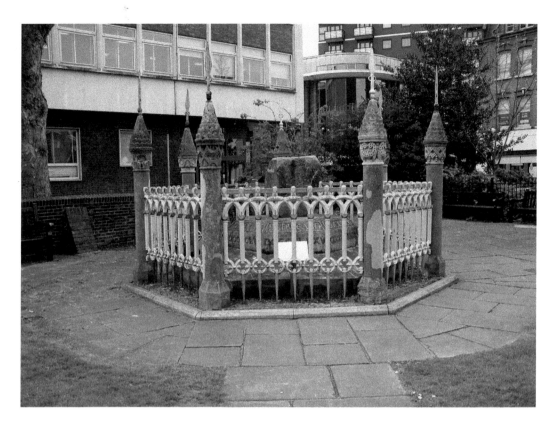

**The Coronation Stone**

Featured earlier in the book at the southern end of the Market Place, the Coronation Stone now sits outside the Guildhall on a platform above the Hogsmill Stream. In 2016-7, it is hoped the Coronation Stone will be moved to the north side of All Saints church; a more prominent position and closer to where the Anglo-Saxon kings were crowned.

# Acknowledgements

Thanks go firstly to Kingston Museum and Heritage Centre who have kindly allowed me to use some 80 old photographs from their collections. The old photographs on pp. 15, 32, 62, 64, 65, 71, 72, 80, 82, 83, 84, 93 & 95 are from my wife Shaan Butters' postcard collection. The old (1970) postcard on p.6 is © J. Salmon Ltd, Sevenoaks, Kent, and I thank them for permission to use it. I have pursued other possible copyright issues but found none outstanding. My apologies if I have breached someone's copyright in error.

For the information herein, I again thank Jill Lamb and Emma Rummins of Kingston Local History Room, Julian Pooley of Surrey History Centre and my wife Shaan Butters, especially for her *That Famous Place: A History of Kingston upon Thames* and various unpublished church notes. I must also thank June Sampson for her articles in the Surrey Comet and her many books on Kingston, especially *All Change, Kingston Past* and *The Kingston Book*.